PRAISE FOR DR. VENUS

"DR. VENUS HAS TAKEN THE PAIN OF HER PAST AND TURNED IT INTO HUGE PROFITS!"

"I consider Dr. Venus the 'Queen of Self-Esteem.' I've had the privilege of watching her produce unprecedented results over and over again. This woman knows how to make it happen in a big and impressive way!"

Lisa Sasevich
"The Queen of Sales Conversion"
The Invisible Close

"DR. VENUS IS A MASTER TRAINER WHO ACTUALLY DELIVERS. HER INCREDIBLE INSIGHT, WISDOM, AND BRILLIANCE MAKE HER ONE OF THE BEST AND BRIGHTEST IN BLACK AMERICA TODAY."

"I am picky. It normally takes a speaker up to 3-5 years to get on the PowerNetworking stage. Dr. Venus did it in three months. This sister knows what she is talking about and she consistently produces incredible results."

"She is serious about empowering our people economically, not simply motivationally. Dr. Venus is a master trainer who actually delivers—which is why I invited her back to my stage and made her part of my faculty."

George C. Fraser,
CEO, FraserNet, Inc.

"DR. VENUS IS AN UNSTOPPABLE SPEAKING FORCE THAT ANY GROUP OR INDIVIDUAL WOULD BE BLESSED TO EXPERIENCE."

"Dr. Venus shows up, turns it out, and moves a room in a profound way. As a 21st century thought leader she pulls inspiration and commitment from the depth of her being and touches every heart, soul, and mind in her path. Dr. Venus is an unstoppable speaking force that any group or individual would be blessed to experience."

Suzanne Evans
Chief Movement Maker

"THANK YOU, DR. VENUS, FOR MAKING OUR BUSINESS STRONGER AND 50% MORE PROFITABLE!"

"Working with Dr. Venus Opal Reese raised our consulting business to the next level. We knew we were undervaluing our work but didn't know how to ask for more. Dr. Venus helped us separate self-esteem from self-worth and made us recognize and explode the emotional barriers holding us back."

Seraphina Uludong
Cabral Consulting

"SINCE I COMPLETED STREET SMARTS FOR CEOS I WAS INVITED TO DO A TED TALK! I HAVE LEARNED HOW TO EMBRACE ALL OF WHO I AM AND BECOME GENUINELY PROUD OF WHO I AM."

"Dr. Venus Opal Reese has been a gift to my life. I have learned how to break through my self-imposed limitations.... By practicing her tools, I have been able to advance in my job, lead projects more effectively, and create a passionate and mutually beneficial relationship... I can't say enough about how this has changed my life and made me a more loving and compassionate person, especially towards myself."

Dr. Roni Ellington
STEM Education Consultant

The Black Woman Millionaire

A Revolutionary Act that DEFIES Impossible

Creator and CEO of Defy Impossible, Inc.
The Black Women's Millionaire Mentor™
Dr. Venus Opal Reese

To Nanna.
Thank you for saving my life.

Thank You for Taking the Step to Change Your Financial Future!

Sis, you're holding a powerful tool in your hands – one that can change the financial trajectory of your entire family for generations to come. I understand that might be hard to wrap your head around – so I wanted to bring you the powerful, personal stories from some of the Black Woman Millionaires who have walked this path before you.

It's my gift to you:

The Black Women Millionaires+ Virtual Salon Interviews

You'll hear from 10 Black Woman Millionaires and 5 Brother Millionaires to learn their stories. They're powerful, raw, and life-changing. This is a $1187 value – and you get it for free just from purchasing "The Black Woman Millionaire: A Revolutionary Act that DEFIES Impossible".

PLUS you will receive access to FREE gifts from each of the Sister Millionaires, Brother Millionaires and Sister Millionaires In-The-Making! Each free gift will get you one step closer to YOUR seven-figure destiny!

To claim your gift, go to http://www.TheBlackWomanMillionaire.com/gift

CONTENTS

OVERVIEW: SETTING THE CONTEXT

Pick one:
1.) Healing the historical hurt that shapes Black Women's relationship to our money and ourselves; 2.) or ... Sister, we are bigger than our bruises. When you heal your heart, you heal the world; 3.) or ... Due to the residue of slavery, Black Women's relationship to money is fucked and how to heal it.
#ifavor#3

As a young , poor, damaged Black girl growing up on the streets, eating out of trashcans, and sleeping in urine and beer, I knew that that there had to be more to life than this piss-ass existence I was born into. But I didn't know how to get out. All I could see was death, hoin', drugs, 5-0, and survival. It wasn't until my ninth-grade math teacher helped me—with food, clothes, and a safe place to sleep—that I realized that I was bigger than my bruises. That I wasn't a piece of garbage that could be kicked around and thrown away. She taught me through her actions that I mattered. It's because of her love that I am alive ... and whole. This book is a love note to Nanna, my ninth grade math teacher. I want to be for Black Women who Nanna has been for me and my broken life: my champion. She showed me new worlds and taught me to like me—broken and bruised.

I have been able to take my brokenness and turn it into millions.

I knew I needed to write this book when I was doing my Black Women Millionaires Blueprint annual tour. Sisters flew in from all over the United States—plus Canada, Belize, the West Indies, and Africa—just to see a real Black Woman Millionaire who was just like them. I don't look like Halle Berry. I'm not refined like Dr. Maya Angelou. I am just a regular ol' Black girl from the streets who has tried to made good with her life. Sisters wanted to work with me, but would burst into tears when they found out my rates because their money wasn't right at that time. Even after I made the entry fee only $47, sisters struggled. Not all, but enough for me to realize that I needed to write a book to get this advice in the hands of every Black Woman who is more committed to her future than her past.

Black Women have inherited a history of hurts that directly impact our relationship with money.

I want to teach Black Women something Nanna taught me, that gave me some breathing room to heal: that it wasn't our fault. Because we are so used to being blamed for everything that doesn't work, we (generally speaking) blame ourselves. But the truth is, it didn't start with the sisters I met on tour.

Black Women have inherited a history of hurts that directly impact our relationship with money. There is a "cultural consciousness" that we traffic in that derives from the institution of North American slavery. Until that wound is addressed and healed, our relationship with money will continue to be fucked.

Let me show you exactly what I mean. Check out these stats:

- According to Nielsen, by 2020 African American buying power is expected to reach $1.4 trillion, of which African American women control over 60%.
- African American women-owned businesses employed 272,000 workers and generated $44.9 billion in revenue in 2013.
- The number of companies started by African American women grew nearly 258% from 1997 to 2013.
- African American-owned businesses are the fastest-growing segment of the women-owned business market and are starting up at a rate six times higher than the national average. (Can you say "financial leverage"?)

There isn't a book in the marketplace that speaks directly to Black Women, by a Black Woman Millionaire, about how slavery has us in emotional and economic bondage—and how to set Black Women free. This book is the antidote to a condition that has been 200 years in the making.

And I say it's right on time.

This is the best time in human history for Black Women to make paper. We are the most educated group in North America, and yet sisters are only making 66 cents for every dollar a White Male makes for the exact same work. We have access, resources, and opportunities our ancestors could never have imagined or prayed for. And yet, we still settle for what others say we are worth.

(I am about to go on a rant for the next couple of sentences. Stay with me.)

I am SO sick and tired of Black Women getting pats on the back but not paid. What pisses me off the most is that we tolerated it. We let ourselves be pimped because we are too cowardly to try. We want security—except security is a false prophet especially if you are slavin' in corporate. So until Black Women learn that it's okay to make our own money instead of hoping someone will notice our efforts, believe in us, or show us favor, African Americans will stay at the bottom of every economic and social measure.

[handwritten margin note: this is why I feel invisible]

No.

Not. On. My. Watch.

In this post-Obama era, in a globalized economy and with the reach of the Internet, there is no limit to earning potential—except internally. So if we are to turn the tide on our money so our children's children are not locked into a caste system that is eight generations deep, we need to take on healing at the level of community.

Now's the time.

With the Black Lives Matter Movement impacting our national civic conversation as well as sisters like Gabby Douglas and Simone Biles sweeping the 2016 Olympics, to Lupita Nyong'o, Viola Davis, and Taraji Henson making history in television and film, to Oprah teaming up with Weight Watchers, this book couldn't be more timely. Why? Because now Black Women are in a place where we are SEEING that we can have a voice, are

more visible in positive ways, and can be a standard—be it beauty or accomplishment. Real talk: Being a Mammy or a "Hoochie Momma" is not inspiring. #justsayin

Sisters are hungry to bet on themselves, to heal, to break generational curses.

But they need a guide. And they need a guide who looks like them, talks like them, and has been where they are. I have gone from the streets to a Stanford PhD to a Black Woman Millionaire. My story inspires; my principles instruct. I am uniquely qualified for this conversation at this moment in history with my sisters in success.

The obvious question is how?

How do Black Women harness historical wounds (that have become survival-based strategies) into seven-figure success?

I have talked with you about the wound; let's now talk about the salve.

As a tenured professor I am very aware of various learning styles. Some people learn best by reading, others by writing. Some learn best by speaking, while others learn best by listening. Most people learn best through stories. So this book is written to instruct in two ways: through storytelling and action items that each sister can apply immediately to her life.

This book is divided into four sections: History, Residue, Spirit, and Strategy. In each section, there are three chapters that each begins with a story. At the end of each chapter there are specific actions each sister can take to heal emotionally so she can thrive financially. Think of the stories as the wounds and the actions being the salve or antidote to the wound.

Let's look at each section together so you can prepare yourself for this walk:

We start by evoking the emotional memory of African Slave, the Middle Passage, the Auction Block, and North American Chattel Slavery. Why? Because it is this singular experience that defines Black Womanhood in the USA. The principles can be applied to Apartheid and Colonialism, but as an Identity Theorist/Performative Scholar, my research from Stanford focuses on North America.

Chapter One focuses on the history of hurts we as Black women have inherited. By highlighting the historical hurts, sisters can all get on the same page with me right off the bat. Chapter Two explores the next emotional space

Black Women must confront: how the institution of slavery has shaped our relationship with money. This is a radical notion.

Most people have NO idea they have a relationship with money, let alone an inherited one. But we do. As long as a sister doesn't realize this extraordinary truth, she will never be able to emancipate herself. Freedom is an inside job, which is where Chapter Three comes into play. There is a certain level of resentful audacity required to break free from emotional bondage to become economically free.

That is why becoming a Black Woman Millionaire is such a revolutionary act.

It's revolutionary because it's NOT about the money. It's about shedding generations of social positioning of being taught, told, and treated like a piece of feces. For a piece of excrement to have the audacity to produce; to give herself

There is a certain level of resentful audacity required to break free from emotional bondage to become economically free.

the internal permission to prosper; to break away from every slur, every rape, every broken dream instead of shriveling into a tight ball of resentment and bile? That's revolutionary. That's some Nat Turner shit in the most extended sense.

While Part One focuses on history, Part Two drills down into the residue of history on Black Women's internal permission to make money. The incident is one thing; the fallout is another. Most Black Women have been taught to believe that we should be grateful for whatever little bit we can get. So we don't ask for the sale, the bid, or the raise.

In Chapter Four we make a distinction between two different kinds of money: self-esteem money, which is rooted in psychology, and self-worth money, which is rooted in valuation. Here I break down the difference and show you how to get both. Once you shift your focus to making money from the value you naturally bring to life, now it's time to give yourself permission to do it. Not simply to make money; but really prosper.

When you prosper, you can write the check, and in Chapter Five we walk through exactly how to do so.

Sisters have been socially rewarded with acknowledgement, inclusion, and acceptance by knowing how to "get by" or make a dollar out of fifteen cents, so we come from a place of survival. Survival strategies are behaviors that

both work and sabotage. What's worse, since the most popular of these behaviors where passed down generationally as demonstrations of what it means to be a "good woman" or a "independent" or "strong" sisters have proof that what they do works for them. And it does—up to a point. They work for "getting by"; they do not work for seven-figure success.

In Chapter Six we look at how your survival strategies are your self-image. Here we cover how to seduce your survival so it works for you instead of against you. Your self-image is the driving force behind performance. Until you tend to your self-image, you will continue to be surprised why you keep shooting yourself in the foot when it comes to your actions matching your words—especially when it comes to money.

Black Women have been taught that money is a tangible object just as our bodies—breasts, back and womb—have been treated like objects. Let me make it plain: historically we have been treated like objects, so we relate to money like we have been related to: something to be used, ignored, trashed, pimped, exploited, plundered and tarnished. In street language we treat money they way we have been treated: like a punk-ass bitch

When I started to realize that money was actually God (i.e., Spirit, currency, energy, etc.) made manifest, I started to honor money as a demonstration of the abundance of Spirit made real in my life. My world transformed when I shifted from relating to something I could see to a phenomenon I could feel in my heart and body, coursing through my veins.

Chapter Seven focuses on shifting one's relationship to money and creating a clear channel for money to show up in your life: your heart. You can't access Spirit and all the goodness that is your divine birthright, by making emotional and energetic space, if your heart is clogged up like a toilet. This chapter is all about unclogging your heart. Once you learn to unclog your heart now you have to deal with the actions you have attributed to "making money." This one took me a minute to get. But when I did, I stopped slavin.

Chapter Eight is all about going from "making" to "manifesting." It's a big deal. It's an energetic shift that requires a level of healing and trust most people can't do. I will walk through how to make this shift and if you take it to heart, it will empower you to stop slavin', working hard, and over-giving. One of the biggest myths for Black Women is working hard will make you rich. But it's a lie. You can do all the right actions in the wrong energetic and struggle with money to the day you die.

In Chapter Nine, we bust the myth around doing things "right." Doing things right or being a perfectionist are damn near guarantees that your money will never match or exceed the effort you put in. Here we focus on the energetic you take actions in instead of the action.

Part Four is all about how to be in action when your survival or history kicks in. In Chapter Ten I unpack one of the most powerful practices I have ever created: leaning into the P.A.I.N. (Plausible Alternative Interpretation Now.) This simple but powerful methodology saved my spirit and helped me to get up off the mat when life would kick me in the teeth.

Another extremely powerful practice I employ with myself and clients has to do with finding money that's in plain sight. In Chapter Eleven we walk through a proven method of moving from "I can't." to "How can I?". Until you develop the habit of coming from "If I could, how can I?", you will literally not see money that is right there. It may not be rolled in your sock underneath the mattress, but it's there.

In our final chapter we tap into the God within. Chapter Twelve is where you come face to face with your own magnificence. Here you realize and embrace that you are not your wounds. You are the answer to millions of people's prayers, and your life has prepared you for such times as these.

HOW TO USE THIS BOOK

Each chapter has a series of action items you can implement immediately so you can make these teachings real in your life. The exercises are very emotionally intimate and very doable. I invite you to do them as you go through the book and then revisit them after you have read the entire book.

Why?

Retention.

I was a university professor before I became an entrepreneur. I know how to teach. I want this book to be revolutionary and life changing for you. So I invite you to love yourself enough to do the book the way it's designed. Reading it is one thing; implementing it will give you a different future. A future that is worthy of your walk.

INTRODUCTION

I don't know if I should apologize first or ask for permission.

The truth will set you free, but first it will piss you off.

It will insult you—to your face.

So maybe I should ask permission first.

Well, not from you. From your survival.

Look, sis, do I have permission to tell the truth about why you are not a black woman millionaire—yet?

Can I just talk to you, sister to sister? No pretense, no political correctness, just real and raw?

(This is going to sound sooooo bad …)

I can tell you why your business hasn't bloomed.

Why you stay at a job that is beneath you.

Why no matter how hard you work, or how many degrees you get, you live paycheck to paycheck.

(#realtalk. If you want to know how you feel about yourself, check your bank account. And if you really want to know how much you value yourself, check your savings. It will tell you all your business to your face. And it will not be sorry for any of it. #justsayin)

I can tell you exactly why you stay in that dead-end relationship where you have to buy love for scraps of respect, or support family members who drain you financially and emotionally, to keep the peace and be thought of as a "good daughter."

I can tell you the real reason you lie awake at night tired, stressed, and sleepless: because no matter how much you slave at your business or at that job or in that cubicle, you never feel like you are enough or that you make enough.

Do you want to know the truth about why you make big moves and big money #iseeyou #makeyourpapergirl but you are "cash-flow poor"—regardless of your high net-worth tax bracket?

Really?

Ready?

Okay.

Take a deep breath in through your nose and exhale through your mouth.

Do it again.

(I'm serious. You are going to have to breathe through this one …)

Deep breath in.

Exhale.

Sweet.

Beautiful.

Sis, if you count all the money you have made at various jobs over the years, you'll come face to face with the fact that you have already made millions of dollars—for somebody else. But not for yourself. Go ahead and do the math. It will piss you off. And it should.

The reason you have made millions for others instead of for yourself is simple and coarse …

Your. Relationship. With. Money. Is. Fucked.

(I'm sorry. I know it's harsh. But hear me out. Stay with me.)

As a brilliant, beautiful, and purpose-driven black woman entrepreneur, expert, or service provider, you and I have inherited a history of hurts that literally birth and continue to shape our relationship with money.

Walk with me …

Think back.

Way back.

African slavery.
Chattel slavery.
Colonialism.
Apartheid.

Think back.

Jim Crow.
Reconstruction.
Plantation.
Auction block …

Imagine, for a moment, that you and I are spiritual beings having a human experience.

If we are Spirit, then we are connected to each other and we are one with our ancestors.

That means we are a part of a cultural consciousness that can't be seen, but can be felt in the silent tears of broken dreams.

If you can jive with that theory, then it's not a stretch to take the case at the level of consciousness that you and I as Black Women are directly connected to a historical wound.

The historical wound is located in our black female bodies that were bought and sold and pimped.

Walk with me.

If you and I are consciousness, that means we are connected energetically. Just as you can feel the presence of a loved one who has transitioned from physical form to spiritual form.

And if we are connected to each other, then we are also connected energetically to the ancestors.

So that same woman who was ripped from her home and sold into slavery to a warring African tribe, who was traded for a trinket to cross the Atlantic in a boat where flesh and feces congealed, whose body was turned into a factory for the American Dream …

You and she are one.

Stay with me.

Imagine being on the auction block, watching as your children are sold into slavery for a bag of rice or 50 bales of cotton.

Imagine your man being forced to "mate" with your sister to produce more free labor.

Imagine having to work hard, acquiesce, or feign affection simply to stay alive.

Imagine yourself cutting cane or picking cotton under the scorching eye of the July sun, proving with every knee bend and hunched back, pulling the tough and tender wool-like fiber from its bud, that you are worth keeping. So you are not sold away from Big Momma, Uncle Ted, Aunt Mae Anne, and the rest of your family into a cruel and unknown evil.

Imagine living under the ever-present threat of the flick of the lash tearing your flesh to shreds if you don't fetch a good price.

If you really think about it, your body, your babies, your man, the wholeness of your family and your physical safety are at the mercy of currency—whether it's cowrie shells, cotton, or cane.

Everything bad that has happened to you stems from money.

If you can walk this out in your mind's eye and heart, you will realize that your relationship with money is tattered and tarnished. That it is battered and bruised.

Not money itself, but your relationship to it.

Just as you have a relationship with a lover or with your child, you have a relationship with money. It was <u>created in a context of survival</u> and has been passed down from one generation to the next.

And if you don't think you have one … well, that explains why money keeps leaving you.

Whether you realize it or not, you do have a relationship with money. Check for yourself. Examine your life and tell the truth to yourself. Right here. Right now.

In your relationship with money you:

- hoard it
- abuse it
- hide from it
- ignore it
- get rid of it

Here's why.

Black Women—at the level of cultural consciousness—are wired to survive.

Due to the history of hurts we have inherited from the institution of slavery, our ancestors created a series of behaviors that served as survival strategies to stay alive, including:

- working hard
- being strong
- acquiescing
- fitting in
- playing it safe
- earning it
- proving it
- overcoming it
- making it

These survival strategies became cultural traits, undistinguished as such, and have now become our "normal."

Look, sis, being strong is not a character trait. It is a survival strategy our ancestors employed to get through slavery. It was passed down from our mother's mothers and the absence of our fathers.

Here's how you know it's a survival strategy: <u>you can't not do it.</u>

Your self-image is rooted in survival strategies that have made you successful but are sabotaging your seven-figure future. This chart reveals how your self-image has worked for you, but how it's now working against you.

Survival Based Self-Image Sabotage: What Got You *Here* Won't Get You <u>There</u>!		
Self-Image	**Survival Strategy**	**Result**
independent	do it yourself	burn-out
nice	never say no	doormat
go-getter	never satisfied	high turn-over
dependable	don't make waves	passed over
hard worker	workaholic	family/body stress

Your self-image was created in a moment of crisis when life broke your heart.

When life breaks our hearts, we create survival strategies to keep us safe.

The survival strategies we create are based on our experiences and what we witnessed in our environment. If you saw your momma be strong and work two jobs to take care of her children, your survival strategy will reflect hers—or run in the opposite direction. You will do exactly what you think you have to do in order to survive and reiterate who you are for yourself (i.e. your self-image).

When you're threatened, your brain and body react as if your very life is at risk of dying a violent, horrible, and cruel death. In terms of survival, the expiration of the body is just one form of dying. There are various sorts of death: emotional trust, physical safety, spiritual connectivity, financial affluence, and social standing.

For example, say that your self-image is independence. The survival strategy of being independent was born when someone you loved betrayed you. You decided to never trust others again and became masterful at not needing anyone's help.

And it worked. You made your way in this world by the sweat of your brow.

You made it to the top—whatever that looks like for you.

But now as an entrepreneur, your business has stalled. Why? Because you don't trust anyone to do things "right." Which means you have to do it all yourself.

Your inability to delegate keeps your business growing at a snail's pace. And you're exhausted. Yes, your survival strategy of doing things yourself kept you from being hurt and betrayed, but it has also kept your million-dollar future at bay.

And it's kept you lonely.

An independent woman by day who works like a slave looks impressive—until you have to go home to an empty bed … and empty life.

The reason you have not been able to multiply your money is that you have been working on the wrong thing. You have been working on you—your feelings, self-esteem, and your mindset—especially your mindset.

In street parlance: willpower is survival's bitch.
Survival will pimp-slap willpower all day, every day.

You have not been tending to your survival.

The reason you haven't been able to change or do something different is because your feelings, self-esteem, and even your mindset assume your willpower will save the day.

Willpower presupposes volition.

Survival is pure stimulus and response.

When a car swerves into your lane on the highway, your foot pumps the brake and your hands jerk the steering wheel to move the car out of harm's way. Even if the threat is imagined. What if the car swerving into your lane was really a bird flying too low?

Your brain cannot tell the difference between a real and an imagined threat.

It just reacts by releasing chemicals that cause your physiology to take over. Your mind creates a story afterward that matches your self-image.

So when I say you are working on the wrong thing, I mean you have, we have, spent years working on ourselves and trying to change our minds about ourselves through willpower.

Survival ain't having none of it.

In street parlance: willpower is survival's bitch.

7

Survival will pimp-slap willpower all day, every day.

That's why when you are threatened, you can't stop yourself from doing things you know are going to wreak havoc. You know if you say that one thing, all hell is going to break loose. You know that eating the cookie completely undermines your diet. You can feel your feet walking down the street away from that networking meeting—but you can't stop.

No amount of willpower will keep your mouth closed when you feel like you are not being heard. So you have to get the last word in—and that's when you lose the sale. Willpower flies out the window when you feel dumped, so you emotionally eat to feel some sort of comfort. When you are threatened, your willpower doesn't stand a chance.

And all the affirmations, mindset mantras, and prayers in the world won't do shit the moment your knee-jerk survival-based strategies kick in.

So when it comes to your relationship with money, you are in a constant state of low-level survival.

(I know. It's a lot. And you're doing great. This is a lot to take in. But don't worry. There's hope …)

With all that being said, please know this: survival is not inherently bad.

In fact, survival is not bad at all. Actually, it is quite useful. But it has its limits.

It's not going away, and you can't change it—any more than you can change your skin color.

Survival is rooted in a history of hurts that shape our personal performance.

AND it has worked for you. It got you out of the ghetto. It landed you that good job. It got you a "good education" or a relentless work ethic, degree be damned. But what used to work now undermines you: because survival can only function in a space of fear, lack, and doubt.

Money can't manifest in a condition of survival.

(Look, sis, I am about to go woo-woo on you. But hear me out, okay?)

Black women have historically been trained and socially rewarded for working hard. We have been taught and told to "earn" money by "doing" something.

Making money through physical effort is a leftover from slavery.

#Real talk: working hard will never make you rich. In fact, it will keep you broke.

Working-class people make money off of what they do.

Rich people make money off of what they know.

If you are serious about becoming a black woman millionaire, one of the fundamental healings you are going to have to do is transform your entire paradigm from making money through your effort to manifesting millions through your energy.

Here's the big revelation that we as black women were never taught: money is a heart condition, boo.

Think of it this way: money is energy. It is currency. And in order for currency to flow, it needs a conduit to manifest in material form. Just as electricity needs a conduit to transmit light into your living room, energy needs a conduit to manifest money into your bank account.

That conduit is your heart.

So when you are dwelling in the negative, harboring anger, resentment, jealousy, regret—all the low vibrational tones—you are energetically blocking your blessing.

When you are in survival mode, you could be doing all the right actions in the wrong energetic while wondering what's wrong with you.

There is nothing wrong with you, baby girl. I know as Black Women we have been positioned as the workhorse, cash cow, beast of burden, and the scapegoat for other people's dreams.

We have been taught and told that we are the problem. We have been positioned at the bottom of the socioeconomic value system. So we put ourselves at the bottom of our lives. We function in a state of low-level survival as a way of moving through this world.

And you can't make money when you are energetically in survival.

It's extremely hard to make money when you need it, and you cannot make money when you are angry. Your survival will become desperate and repel all the goodness that is your divine birthright, no matter how hard you work.

So if you are serious about becoming part of that two percent of women in business—of all races—who ever break the million-dollar mark, you need to focus your attention and intention on tending to your survival.

(Stay with me. We are almost there ... you're doing great.)

Look, sis, I don't want you to try to change or get rid of your survival.

No.

I want to teach you how to seduce it.

To harness it as rocket fuel for your seven-figure destiny.

The key to harnessing your survival is healing your heart of historical, cultural, societal, and personal wounds that keep you undercharging, hiding in plain sight, slavin' at a job you hate, playing small, and living a mediocre life.

I turned my survival into a multimillion-dollar, home-based business in less than four years.

I harnessed my survival into four degrees, including a second master's degree and a PhD from Stanford University.

I used my survival to keep me alive when I was a teen living on the streets of Baltimore, eating out of trashcans and sleeping in urine and beer.

As far as I am concerned, becoming a black woman millionaire is a revolutionary act.

It's telling history to kiss your black ass. (#andimeanthatshit)

When you become a black woman millionaire, you move from being the capital to providing the capital.

And be very clear—being a black woman millionaire is not about the money. The money is the easy part. It's the healing part that's the motherfucker.

In truth, you have already made millions for others over the span of your adult working life—and student loan compound interest. Why not emancipate yourself emotionally to make millions for yourself?

Being a black woman millionaire is about <u>freedom.</u>

 It's about letting your life shine so brightly that the millions of people for whom you are the answer to their prayers can find you—and pay you top dollar.

It's about opening your heart to receive all the goodness that is your divine birthright.

It's about allowing the world to handsomely reward you for the inherent value and intrinsic worth you naturally bring to life itself.

Dream with me and imagine …

… if every black woman on the planet healed her heart; sisters around the world stopped seeking validation and stood for themselves with the same fervor they have for protecting their kids …

… every brilliant and beautiful black woman free of money concerns; no longer having to kiss ass to collect a check …

… every sister funding her own dreams, inventions, and technologies, easily and effortlessly …

What would happen in the world if Black Women en masse went from being employees to entrepreneurs and raised our daughters to have their own?

Imagine, my sweet sister in success, having so much wealth you can write the check. To retire your parents, fully fund each child's college education, pay for your dream home in cash, and alter the financial affluence of your bloodline.

All of this is just a few pages away.

If I can heal my heart to harness my survival—

If I can monetize my mess by cashing in on courage—

If I can dollarize my disappointments to pimp my pain for profit—

If a poor little black girl from the streets can heal generational wounds; have Hollywood production companies woo her for her own TV show; buy her first million-dollar home with ease; travel first class from Costa Rica to Cambodia to Canada on quarterly vacations with her wife; rock a Rolex, drive a Mercedes-Benz, and live a lifestyle you and I only saw white people living on TV when we were growing up …

… so can you.

Why?

Because you and I are one and the same.

We are spirits, connected to Spirit.

The Dalai Lama is known for having said that it will be the Western woman who will save the world.

I say it will be the healed black woman who transforms it.

YOU are that woman.

You are the dream our ancestors slaved for.
You are God wrapped in flesh.
You are the way, the truth, and the light.

When you heal your heart, you heal history.

And when you heal history, you heal the world.

Let me show you how.

HOW I DID IT:
FROM THE STREETS TO STANFORD TO
BLACK WOMAN MILLIONAIRE

"Get your stupid ass out of my house!" Momma sneered as I stumbled down the three-step marble stoop Baltimore is known for. I was too angry to speak and too numb to care. I just needed to get away from Momma before she could lay her hands on me—again.

We had gotten into an argument because Momma didn't like it that I had left earlier with one male friend and had come back later with another. She called me names: Bitch. Whore. Slut. I hadn't done anything with anyone, but she didn't believe me.

She never believed me.

She cornered me in the kitchen. We lived in a condemned building on Jefferson Street. The window in the kitchen was boarded up and the door had spaces we tried to fill with blankets. It didn't work. The rats ate right through them. "Who do you think you are? Huh?" She squinted as she went to the dirty stove with the can of refried Crisco grease. On the stove was a rusty knife with a chipped, stained wood handle and a blade that turned down at the tip. Momma grabbed the knife and got in my face:

"You want to fight me, huh? Swing, bitch, swing!" She screamed in my face. I saw red.

Like waves of heat rising up off of pitch-black asphalt in the middle of July, I was so angry … at the unfairness of it all. I felt myself throw my hands up—not out. I screamed, "I am not going to fight you, Momma. I am not going to fight you!"

Momma froze.

I don't know if she paused because I spoke up or because I didn't hit her. But that pause gave me enough time to get around her and out of the kitchen, just as I felt the breath of the knife miss my back. She started to pound my back, my shoulders, while she yelled that I was a piece of shit and that she should have flushed me down the toilet when she had the chance. I keep going toward the door. And then she pushed me out of the house with the full force of her contempt for me, for my life.

"Get your sorry ass out of my house, you ugly dumb ass. You ain't shit. Just like your daddy. You ain't shit. I wish you had never been born!"

At the bottom of the stoop, I turned around and looked at her—all brilliance, beauty, and fury, a beautiful Black Woman that life had turned into "Momma"—and knew I would never come back again. This wasn't the first time she had put me out. That had been going on for years.

And I knew the drill.

Get a beating. Broomstick. Water hose handle. Extension cord. Stay gone for a week or so. Sleep outside, or at a friend's or relative's house—whoever had housing at the time—and then come back on my knees and say I am sorry for making Momma hit me. But I couldn't. I was 16 years old, and I realized I wouldn't go back. Why? Because I couldn't promise myself I would throw my hands up instead of out. I couldn't guarantee that I wouldn't put my hands on her.

If I ever hurt Momma, it would kill me.

I could no longer protect her from me.

So I took to the streets.

There are a lot of stories I could tell you about what happened on the streets. But I won't. Not here.

Why?

Because I don't want you to worry about me and I want to focus on you. Your life.

That being said, here's how I went from the streets to Stanford …

One day, while I was sitting on my street corner, Monument and Federal Street in Baltimore, Maryland, steeped in piss and beer, I prayed. It was a simple prayer: "God, please help me." That prayer ordered my steps to Northwestern High School—dirty, smelly, and too ashamed to lift my eyes from the floor. It got me to the woman who saved my life.

(There's so much to share. God, please help me tell it right so it does what you intend it to do ...)

I fully expected to be dead by 20, hoin', strung out, or on welfare with four kids. You don't know this, but my oldest sister died due to heroin laced with embalming fluid, my brother had been in and out of jail for selling drugs, and my baby sister was pregnant by 16. My life is a miracle. So when I say my teacher—let's call her Nanna—saved my life, that's not hyperbole.

Nanna is about 4'10", fair-skinned, with an attitude problem. When I came to school that day (because I could eat there), and the kids were calling me "piss-rag" and "dirty bitch," while laughing and pointing, Nanna yelled down the hallway and to the students piling into her math class, "Venus, go sit in my classroom NOW! If anyone else says ANYTHING to Venus, I will give you a zero!"

I sat in the back of the class and didn't say anything. But for the first time in my life, I felt protected.

To say thank you, I stayed after school and wiped down the blackboards filled with yellow and white chalk marks. It was messy, but I wanted her to know I appreciated her speaking up and helping me.

"You hungry?" Nanna asked in a gruff voice.

I just looked down and nodded. She took me to McDonald's and we ate in the car. She asked me where I lived, and I stopped chewing. I was ashamed that I didn't have a place to stay and I didn't want to tell her about Momma.

So I said nothing.

She then asked me what part of town she could drop me off at. I sighed. I told her Monument Street. So she took me there. When I got out of her car, Nanna said, "Come back to school tomorrow. I have something for you."

So I went.

On the seat in the back row of her classroom was a bag that had Hanes underwear(still in the wrapper!) socks, deodorant, soap, toothpaste, and a toothbrush. I didn't say anything. I just wept. And I stayed after school and wiped down her blackboards, and then she took me to eat. This went on for

months. Sometimes she would leave a book on my chair, other times a college pamphlet. And I felt loved.

I didn't talk or tell (where I come from, you never tell), and one day Nanna came to the back of her classroom where I sat and said to me, "If you are not going to talk, then write!" And she slammed a pencil and a notebook on the desk.

I got scared. She had been feeding me for six months. That's five meals a week. Add her dinners to the free breakfast and lunch I was getting at school, I was covered and only had to fend for food on Saturday and Sunday.

Sure, I knew where all the soup kitchens were, but it was nice to have food covered for five days a week without having to do something for it.

So when she told me to write, I didn't want to mess up a good thing. I wrote down my thoughts. They came out in fragments, like jagged shards of glass. Nanna read them, typed them up, and sent them to the NAACP-A.C.T. S.O. poetry competition—and I won.

The winning was one thing, but the true transformation came when I realized what Nanna had done for me. Keep in mind Nanna was a math teacher. Not English. History. Social Studies. The only way for Nanna to find this contest would be if she were looking for it on my behalf. She had turned herself into a resource so I could see myself with new eyes. She gave me the pen and notebook (tools), so the words on the page became my voice.

And she did it for free.

I didn't have to "pay" her anything. This blew my mind. NOTHING on the streets is free. Usually there is some "payment" to get basics. But not this. Not her. For the first time in my young life I had my very first new thought: "Nanna sees me different from how I see me. I see me as a piece of shit. She sees me as someone who matters. If I could see me like she sees me, maybe I could do something with my life."

That one thought was when I got committed to living instead of dying. That was the day I stopped depending on my survival to stay alive. I got on the same page with Nanna about getting off the streets.

Nanna petitioned for me to be declared independent as a minor so I could get food stamps, join the military, and apply for student loans and grants to go to college. She even had other teachers at Northwestern sign the petition so I had a shot at a better life.

THE BLACK WOMAN MILIONAIRE:A Revolutionary Act that DEFIES Impossible

Nanna took me in. Her sister gave us a sofa bed so I didn't have to sleep on the floor. Nanna taught me how to eat with a fork. (To this day, I still prefer to eat with my hands.)

Nanna paid for me to go on college tours, on her teacher's salary. She bought me shoes that didn't have holes in them, which is what I was use to having. She bought me clothes that didn't come from Goodwill or the Salvation Army. They were new.

She helped me fill out the applications for colleges.

I didn't want to go to college. But Nanna wanted me to go. I wanted to work. Everyone I knew worked. Or sold drugs. Or worked the streets. So I started to rebel. I made Nanna cry. I said bad things. I tried to get her to put me out. I refused to sleep in the bed she got me. I slept on the floor. I cried in my sleep. But when Nanna came in the living room and stood over me, I would sleep.

One night, I woke up crying. I was scared someone was trying to get me. (To this day, I have a fear of unlocked doors.) I went and got in Nanna's bed. I asked her, "Do you love me?" Nanna said, "No." Flat voice. Almost like a nonverbal shoulder shrug.

I felt stunned. I thought she did. I had never asked before, but she acted like she liked me, so I thought she loved me.

"Why not?" I whispered.

Nana sighed and said, "Because you don't do what I say."

From that day to this, I do what Nanna says.

We applied to colleges, and I was accepted at Adelphi University.

Then Ohio State University.

Then Stanford University.

So my story of going from the streets to Stanford is really the story of a Black Woman saving the life of a damaged and thrown-away Black baby girl.

The bottom-line is this: Nanna taught me, through her actions, that I am not a piece of shit that should be tossed away like trash. She loved me through my bruises. She gave me the tools to have a voice, she turned herself into a resource on my behalf, and she poured a love on my wounds (through her actions) that I didn't have to earn, prove, or pay for in any way, shape, or

form, with my body. It is because of her love that I am alive, whole, and a Black Woman Millionaire.

My entire business has been built to do the same for my tribe: provide you with tools so you can have YOUR voice; be a resource to you on your behalf, and pour a love on you that you don't have to earn or "prove it" so you can fulfill your destiny. So many Black baby girls become Black Women who feel they have to "earn it," "prove it," or "make it" in the world, and they never had a Nanna to love them through their bruises so they could defy impossible …

… until now.

PART 1: HISTORY

CHAPTER 1
HISTORY OF HURTS WE HAVE INHERITED AS BLACK WOMEN

In my body
there are memories
that are not mine.

Pains and hurts I was born into.

I thought they had to stay.
I thought I had to keep them.
They were the only link
I had to my past.

I thought.
Had been told.
For generations.

My past
was my birthright.
My birthright
was a lineage.

My lineage
was that of a slave.
An ignoble savage
able to be taken
over
and over
and over
again.

Weak,
stupid,
gullible.

I had been told.

So I believed.
I believed
because
I had been told.

And I was ashamed.

Then I was blamed.
Blamed for the pain
I housed in
this black body.

Blamed by everyone
and everything around me.

I was born to suffer.
I was born into suffering.
Had to fight back.

I began to blame.

There is power

in pointing
the finger.
Righteous
power.
Empathetic
power.
Guilt
power.

I had power
for the first time
in my body
because
I could hold
my
tattered flesh up
and show the world that
I
had been wronged.

But secretly I was ashamed.

My birthright
was a lineage.
My lineage
was that of a slave.
An ignoble savage
able to be taken
over
and over
and over
again.

Weak,
stupid,
gullible.

But
I
had power now.
I
had recognition.
People
looked on
me
as valuable.
I
became
somebody.
A
body.
A
human body.
For the first time
in history,
I mattered
because
I
could hold
my
bleeding wounds up
to the heavenly
sky
and peacefully
beg pardon.

But secretly I was ashamed.

My birthright
was a lineage.
My lineage
was that of a slave.
An ignoble savage
able to be taken

over
and over
and over
again.

Weak,
stupid,
gullible.

I believed
that my birthright
was nominal
and I held on
to my pain
because
it was the only
credence
I had.
It was the only
weapon
I had
with which to
defend
myself.
My hurts
were my only
source of power,
for garnering
visibility,
empathy,
support.

I fed on my pain
because
it was
what
kept me alive.

And anything
that contradicted
that pain
was a threat.

So my pain
had to become
more visible
in order to
keep me
in existence.

My pain
became
my identity
And I wore it
like a badge.

I believed
my pain
was me.

But secretly I was ashamed.

My birthright
was a lineage.
My lineage
was that of a slave.
An ignoble savage
able to be taken
over
and over
and over
again.

Weak,

stupid,
gullible.

Now my pain wears me.

On the streets
and in history
I don't know
any other place to go.
I won't let another
muthafucka
steal my flow.
It's all about
the game
I got to play
to survive.
Stay alive
with persistence
and thrive
off this past,
this pain,
this piss-ass existence.

Fuck what
them other
niggas be
talking about.
I'm survivin'.

Title: In My Body A Performative Narrative in 1 Column.

Black Women are wired to survive.

(Sis, take your time to read this history lesson.

I am starting here on purpose.

If you let it into heart and mind, it will open your eyes about the social position you were born into.

True, it may feel dry and boring to read, but if you don't know how your Black Female Body has been historically positioned, you will think all the shit that's happened to you is your fault.

It's not.

It didn't start with you sis …

That's why this part is so important. #sankofamoment

Will you slow down and walk through this history with me?

It's not very long.

Please say yes.

I'll wait for you to choose…

Ok?

Thank you.)

Walk with me …

… and just imagine

YOU are an enslaved Woman of African ancestry who made it through the Middle Passage, the auction block, and you're now a "maid" on a plantation in the antebellum South …

YOU KNOW YOU ARE A MAID ON A PLANTATION IN THE ANTEBELLUM SOUTH IF …

… in 1619—while not the first Africans to set foot on North American soil[i]— your fore-parents arrived via a Dutch vessel under the command of Captain Jope and piloted by an Englishman named Marmaduke Raynor, who,

in "exchange for supplies," sold approximately twenty of your fore-parents to the local authorities[ii] in Jamestown, Virginia.

… in 1629, in colonial Virginia, a tax was levied on all who were regarded as field laborers, and subsequent laws "defined those subject to taxation as black and white male servants and "negro women of sixteen years,"[iii] In so doing, they placed your foremother—and eventually you—outside of gender conventions and physical safety from both black and white males.

… in 1662, the Virginia General Assembly passed a statute which stated that any children fathered by "an Englishman upon a negro woman"[iv] would follow the maternal lineage instead of the paternal, which was the common law of free people, thereby constructing the legalization of slavery as a hereditary condition.

… in 1668 a statute was passed that stipulated that all free "negro" women "ought not … be admitted to a full fruition of the exemptions and impunities of the English, and are still liable to payment of taxes," thereby creating the legal meaning of Negro synonymous with non-"English" and servitude, even after freedom.[v]

… in 1680 a law was passed that forbade you—and your male counterpart—to bear arms or leave the plantation without a permission slip, and it said that you could legally be killed if you "resist lawful apprehension" for raising your hand against "any Christian" or "absent" yourself or "lie out from" a master's service.[vi]

… you were brought in to the big house between the age of six and twelve to be trained, for "it was widely believed that the best way to develop good house servants … was to raise them."[vii]

… you were not allowed to legally marry a husband, so you were not afforded protection of him or the law from "white" male or other "black" male violation.

… your social position afforded you two perpetuated social identities: that of a "Mammy," who loved her white family; and that of a Jezebel, the exact antithesis of "Southern Lady" whose sexual purity and genteel sensibility was preserved with your body.[viii]

… required to breast-feed your mistress' child instead of your own.

… you were usually more skilled than the mistress at the domestic arts, and while you couldn't "assume the mistress' place," you could, and did, "take the management of the house into" your "own hands."[ix]

… your workday entailed cooking, washing, ironing, nursing illnesses, lifting barrels, sweeping, dusting, hoeing, weeding gardens, collecting eggs, suckling, washing, babysitting, as well as spinning and weaving "household linens and negro clothes."[x]

… some of the strategies you employed to survive the institution of slavery were: acquiescence to master, mistress, and slave, cultivating nonthreatening posturing and ways of speech, repression, lying, stealing, praying, becoming indispensable to the mistress, having sexual relations with the master, internalize racism for field workers, acting stupid, resentment of male slaves who could not protect or provide for you, feigning illness associated with "the menstrual cycle and childbirth," being contrary, humor, "fake fits," manipulation, running away, "the use of poison" to kill masters, speaking up, and silence.[xi]

These survival strategies were passed down generationally. They have become behaviors we have inherited in order to "make it," to survive. Look in your own life. Your being the "workhorse," "scapegoat," "beast of burden," or the "cash cow" are historical behaviors that directly impact your money.

Survival strategies are a cluster of behaviors that automatically kick in when you feel threatened to avoid punitive consequences. These behaviors are passed down by being acted out on your body or witnessed by you in heightened emotional states in your upbringing. If your man saw his daddy beat his momma's ass like his granddaddy beat his grandma, after Massa beat his ass in order to command obedience through fear, your man will likely resort to violence with you. It may not be a physical beat down. It may be a tongue lashing. It may be withholding money until you "perform." It may be leaving.

My point is this: just because the institution of North American Chattel slavery is gone, doesn't mean the survival strategies that made it the bedrock of USA profitability disappeared in the bodies that made it possible. Think about it: the coalminers who breathe in the air of coal for years or the First Responders from 9/11 who dug out half-alive bodies from the debris inhaled poison to help others. Even after the coal had been shipped away or buildings had been rebuilt, the bodies that did the digging and the building still suffered

the consequence; and the consequence was fatal. The same principle applies to the institution of Slavery.

Survival strategies didn't disappear with Emancipation. No. Survival strategies went underground. They became ingested as the way to "make it" in this world.

Take a moment and look in your life at the survival strategies you use to stay out of trouble or get what you want or to avoid death. Now remember: there are different kinds of "deaths" not just physical. There is familial death, financial death, social death, emotional death, and spiritual death.

Use this list to identify which survival strategies you have inherited.

Historical Survival Strategies

- acquiescence
- nonthreatening posturing and ways of speech
- repression
- lying
- stealing
- praying
- becoming indispensable
- having sexual relations with the master
- internalize racism for field workers
- acting stupid
- resentment for lack of protection in household or work
- feigning illness associated with the menstrual cycle and childbirth
- being contrary
- humor
- fake fits
- manipulation
- running away
- "the use of poison" to kill
- speaking up
- silence

You Are Not Your Survival Strategies

Great job. Very brave work. Now let's look in your life again and identify EXACTLY when you started the survival strategies you use the most. What happened? What did you see?

Awesome!!

Now identify your top three survival strategies and how they have worked for you in your life.

Survival Strategy 1:

How it works for me in my life:

Survival Strategy 2:

How it works for me in my life:

Survival Strategy 3:

How it works for me in my life:

Perfect! You are doing great! Now let's go there: Identify your top three survival strategies and how they have worked for you in terms of your money. Be proud! Survival strategies work so don't be ashamed if you did some shady shit for money. You were surviving.

Survival is not about being thought well of or respectability. Survival is ruthless. Just like slavery. It doesn't give a damn about loyalty, family, or fairness. Give yourself the permission here to tell the truth about how you have survived. If you can grant yourself grace to acknowledge and own when your survival has had you do things you never thought you would do or tolerate, you set yourself free baby girl.

Remember: it's not your fault. The only way to stop beating yourself up is to really comprehend that whatever you did or didn't do was a function of you surviving a real or perceived threat. I need you to tell the truth so you can have compassion for you. Okay?

Identify your top three survival strategies and how they have worked for you in terms of your money.

Survival Strategy 1:

How it works for me in my money:

Survival Strategy 2:

How it works for me in my money:

Survival Strategy 3:

How it works for me in my money:

YOU are amazing!! Thank you for being SO brave! It takes something to tell the truth. It does. I am clear you are truly committed to your emotional and economic freedom by the way you are doing the real internal excavation to set yourself free.

There is one more round to go before we move on to the residue: the cost. What did those survival strategies cost you in terms of self-worth, self-pride, and self-efficacy?

Just take a few minutes and write down the cost. And let yourself grieve. Let yourself mourn. A lot of times we can't move forward because we haven't grieved the loss of our own innocence. When survival kicks in, you are not there anymore. Your brain releases chemicals that take over, driving you to either freeze, flee, or fight.

By acknowledging the cost survival has wracked on your sense of self, you start differentiating your survival from YOU. That distinction, that separation, that grace of realizing your survival strategies are not you—that my sister, is your get out of jail free card.

What has been the cost of your survival strategies on your sense of self?

(Have tissues nearby and be in a private place where you feel safe to look truth softly in the eye. Let yourself feel. This is you truly accepting you are not your survival strategies.)

I am so proud of you. You truly are extraordinary. Thank you for healing generational wounds. Thank you for being brave. Now let's go kick the residue of Slavery's ass.

[i] According to Peter H. Wood in Robin D.G. Kelly and Earl Lewis' text, *To Make Our World Anew: A History of African Americans* (Oxford: Oxford University Press, 2000), 53, "Africans were present in the early Spanish forays onto the continent of North America" as early as 1526. I have chosen the 1619 date because these groups of Africans are the fore-parents of the slaves of the Antebellum South plantations.

[ii] Ibid.

[iii] Deborah Gray White, *"Ar'n't I a Woman": Female Slaves and the Plantation South* (New York: W.W. Norton & Company, 1999), 66–67.

[iv] Andrew Fede, *People Without Rights: An interpretation of the Fundamentals of the Law of Slavery in the U.S. South* (New York: Garland Publishing, Inc., 1992), 33.

[v] Kathleen M. Brown, *Good Wives, Nasty Wenches, and Anxious Patriarchs: Gender, Race, and Power in Colonial Virginia* (Chapel Hill: University of North Carolina Press, 1996), 122.

[vi] Ibid., 32.

[vii] Elizabeth Fox-Genovese, *Within the Plantation Household: Black and White Women of the Old South* (Chapel Hill: University of North Carolina Press, 1988), 152–53.

[viii] See Elizabeth Fox-Genovese, *Within the Plantation Household*, 291–92. See also Kathleen M. Brown, *Good Wives, Nasty Wenches, and Anxious Patriarchs: Gender, Race, and Power in Colonial Virginia* (Chapel Hill: University of North Carolina Press, 1996), chapter 4.

[ix] Ibid., 163.

[x] Ibid., 138–39.

[xi] White, *"Ar'n't I a Woman,"* chapter two.

CHAPTER 2
RELATIONSHIP WITH MONEY FROM SLAVERY

When your body has been sold for money, it is almost impossible to have an empowering relationship with it.

Slavery was a business.

Plain and simple. Just like the prison-industrial complex is big business now by villainizing primarily Black bodies (check out 13th by Ava DuVernay on Netflix to have your mind blown!), the institution of North American chattel slavery was a business. And Black Women's bodies were the capital.

Be clear. I am not talking about cotton, cowrie shells, cane, or tobacco.

I am not talking about the tender you touch that stands in for money. I am speaking about our relationship to money. Due to the institution of slavery, money is the enemy. Money has been the reason our bodies have been pimped, our men killed, and our babies sold. Look in your own life and you will see that you have an adversarial relationship with money.

If money were a White Man with limitless power to take your life, break up your family, and make you crawl—you would hate him.

You would plot ways to avoid him, hide from him, kill him, placate him, or just acquiesce to him. So the reason your money hasn't been able to multiply is that you have been focusing on "getting more money" instead of healing your relationship with money. As long as money is the enemy, you will live in

fear. Just like our ancestors did, whenever Massa came around.

Healing requires you to confront fear. It requires you to look your jailer/enemy/abuser/adversary/tormentor/pimp in the eye and say, "No more." Healing requires you to be brave instead of having courage.

Having courage is being afraid and taking the action. Being brave is different. When one is being brave, you know you are about to walk into a shit storm, where there is the very real possibility you will lose—your life, your job, your relationship, etc. And you go in anyway.

Why?

Because you have a bigger commitment to being free than to living on your knees.

Money Mess Twelve-Step Program™:
Healing Your Relationship With Money

PART 1: MONEY BAGGAGE
(The first step to money wellness is admitting you have a problem ... I'm just saying ...)

1. **What do you say to yourself about money? (List your top three sayings)**

2. What did you hear from your family about money when you were growing up?

3. What is your biggest fear about money?

4. When did that start; what happened?

5. What do you have to release, let go of, or forgive _____
regarding money?

- Others

- Yourself

- Life

MAKING AMENDS WITH MONEY

6. Money is a heart condition. What would you have to change in your heart AND behavior to be open to receive? *(It's time to "let" instead of "get.")*

7. Write down how you have abused your relationship with money, taken it for granted, or ignored it.

8. Write down how you will make it right.

PART 2: MAGNETIZING MONEY

9. What do you want your relationship with money to be?

10. What would be your experience of yourself if you had that relationship with money?

11. What can you do in your life RIGHT NOW to have that experience of yourself?

12. Who or what can you give to as an act of inspiration to honor Spirit, access abundance, and experience wealth? _(This is about letting Spirit be your Source—not your efforts. Let Go and Let God. Give. No strings.)_

PART 3. YOUR RELATIONSHIP WITH MONEY IS FUCKED: HEALING THE SEVEN DEADLY SINS

Tell the truth; shame the devil. Considering the history of hurts you and I have inherited, it's no surprise our relationship with money is screwed and tarnished.

Go through these Seven different ways you act out your relationship with money. No judgment. No condemnation. Just truth. Write down for each sin how you punish money for betraying you, pimping you, leaving you, or hurting you in any way, shape, or form. Go to real examples in your life—from bankruptcy to abortions—whatever is your truth.

You have a relationship with money, and you must get present to it if you want to heal this relationship generationally. Some of how you act out with money you inherited from your family. Some has to do with your own life choices. Still other ways you act out how money is the enemy came from other people's betrayals.

The bottom line is this: you can't heal what you are denying. If you want to make money on your OWN terms, you have to heal your relationship with money.

Starting now.

When have you "acted out" how much you _____ money? What happened?

1. Hate money

What was the payoff from having done that?

What was the cost in terms of your sense of self, your self-trust, and your self-respect?

What would you have to do to atone for the damage in your heart of hearts?

What new action do you see you can now take that wasn't possible before? *(Let it be beautiful for you. Make it beautiful …)*

When have you "acted out" how much you _____ money? What happened?

2. Resent those who have money

What was the payoff from having done that?

What was the cost in terms of your sense of self, your self-trust, and your self-respect?

What would you have to do to atone for the damage in your heart of hearts?

What new action do you see you can now take that wasn't possible before? *(Let it be beautiful for you. Make it beautiful …)*

When have you "acted out" how much you _____ money? What happened?

3. Hide from money

What was the payoff from having done that?

What was the cost in terms of your sense of self, your self-trust, and your self-respect?

What would you have to do to atone for the damage in your heart of hearts?

What new action do you see you can now take that wasn't possible before? *(Let it be beautiful for you. Make it beautiful …)*

When have you "acted out" how much you _____ money? What happened?

4. Abuse money (or take money for granted)

What was the payoff from having done that?

What was the cost in terms of your sense of self, your self-trust, and your self-respect?

What would you have to do to atone for the damage in your heart of hearts?

What new action do you see you can now take that wasn't possible before? *(Let it be beautiful for you. Make it beautiful …)*

When have you "acted out" how much you _____ money? What happened?

5. Give away money (or did shit for free)

What was the payoff from having done that?

What was the cost in terms of your sense of self, your self-trust, and your self-respect?

What would you have to do to atone for the damage in your heart of hearts?

What new action do you see you can now take that wasn't possible before? *(Let it be beautiful for you. Make it beautiful ...)*

When have you "acted out" how much you _____ money? What happened?

6. Hoarded money (being cheap or stingy)

What was the payoff from having done that?

What was the cost in terms of your sense of self, your self-trust, and your self-respect?

What would you have to do to atone for the damage in your heart of hearts?

What new action do you see you can now take that wasn't possible before? *(Let it be beautiful for you. Make it beautiful …)*

When have you "acted out" how much you _____ money? What happened?

7. Coveted money (or jealous or envious of others who have more money)

What was the payoff from having done that?

What was the cost in terms of your sense of self, your self-trust, and your self-respect?

What would you have to do to atone for the damage in your heart of hearts?

What new action do you see you can now take that wasn't possible before? *(Let it be beautiful for you. Make it beautiful …)*

CHAPTER 3
ON THAT NAT TURNER SHIT:
BLACK WOMAN MILLIONAIRE AS A
REVOLUTIONARY ACT

He wasn't havin' it.

Nawh, son.

He had been beat one too many times.

He plotted. Planned. Made nice. Held secret meetings down by the riverside. And on August 21, 1831, in Southampton County, Virginia, Nat and his crew didn't run.

No. They rebelled.

His act of rebellion was the revolution.

You see, when you rebel, you require others to deal with you—on your own terms.
Yes, there are some costs.
But the costs pale in comparison to what is gained: self-respect.

Sis, becoming a Black Woman Millionaire is a revolutionary act.

It is you rebelling from all the shit we as Black Women have been born into.

The wounds. The put-downs. The shame. Guilt. Blame. Mistrust.

The money is just the scoreboard.

When you are the sister who writes the check, you just told history to kiss your Black ass.

Here's why.

Becoming a Black Woman Millionaire is a revolutionary act.

We used to be the capital. Now we provide it.

That's revolutionary. But it starts with a rebellion.

An internal rebellion of the history of hurts you and I have inherited.

Think about it.

Each time you doubt yourself, that's history whispering in your ear that "you're nothing," inferior, incompetent, less than.

I know you may have heard those words come out of your momma's mouth or in your daddy's drunken fits, but someone said those words to them.

So they passed it down to you.

Now you say them to your daughter when you're pissed or to your son when you're stressed.

My point is this: when you heal your heart, you are rebelling against a history that didn't give a fuck about you.

And when you have healed enough to let yourself be compensated for your genius, you, my dear, have just done some Nat Turner shit.

You turned your rebellion into a revolution …

Now you are speaking up, instead of talking back.

Now you are able to not be offended by small minds with big mouths.

Now you can command top dollar because you know in your bones that people buying from you are not a reflection of your worthiness but a demonstration of their commitment to themselves.

Now you can invest in yourself because you realize you are your own best thing.

Now you can let life happen because you trust yourself to create money instead of asking for a handout or a shortcut.

Now you have credibility with yourself because you can count on you to invest in you instead of buying validation with degrees and credentials.

Yeah. We on that Nat Turner shit.

We're setting our own selves free.

Remember sis: rebellion is an internal act. It is the precursor to revolution. You can't stand for your money if you don't stand for yourself—*with yourself.* So let's start with you rebelling against all the historical, cultural, societal, and personal hurts that keep you enslaved.

Let's start with a Freedom Ride. Back in the day, 1961 to be exact, a group of student activists launched a series of interstate bus rides to protest segregation. It was a bloody brawl. Yet in September 1961, the Interstate Commerce Commission issued regulations prohibiting segregation in bus and train stations nationwide. The young people—both black and white activists— had to heal internally before they could get on those buses and change the course of human history.

Here is your opportunity to be your very own Freedom Rider.

Be Your Own Freedom Rider

Take out a pen and pad, a journal, or your computer.

Draw your own bus. If you are not prone to draw, then gather pictures or create a Pinterest page for your Freedom Bus.

In the bus, place images, words, or symbols of your internal KKK. Identify what things have been said or done to you that keep you in emotional slavery—historically, culturally, societally, or personally. You can start here and just brain dump.

The wounds.

The put-downs.

The shame.

Guilt.

Blame.

Mistrust.

Betrayals.

Great honesty. You are doing sooooo good!

Now once you have all these bastards on your Freedom Bus, one by one, confront them. Say your peace. Scream. Cut their picture up. Burn the symbol that hurt represents. The point here is to stop being afraid. Everyone who has ever hurt you is a human. They are not better than you. They are not bigger than you any more. If it's a family member, sit in the seat beside them and let them see the damage. Show them the scars. Shed tears of blood and regret. Tell the truth and let the truth go to work.

Make your Freedom Bus be a safe space for you to express your truth, in all of its ugliness. You don't have to be polite here. You don't have to be politically correct. I will not tell a soul. And you don't have to share this with anyone. This is you loving yourself enough to stop having the past have power over you. _It's time for you to stand up within yourself for yourself._

My point is this: Rebel.

Be as violent as you want—on paper. Be as angry as you need to be—on the page. Tear shit apart—in writing and images. You are giving yourself the permission to stand up for yourself with yourself. This is private. You have to confront and stand up to your wounds. When you do this exercise, you will take your power back.

Get ready sister girl; you are creating the groundwork to start your own revolution.

#weonthatnatturnershit

PART 2: RESIDUE

CHAPTER 4
YOU WILL NEVER OUTEARN YOUR SELF-IMAGE, EVEN IF IT IS POSITIVE

Holla at your girl if you are …

- Independent
- Strong
- Nice
- A go-getter
- Dependable
- Hard worker
- Reliable
- Trustworthy
- Loyal
- God-fearing

Sweet. You have just sentenced yourself to a life of hard work, struggle, and self-sacrifice. Each and every one of those words listed above is a self-image. It's who you are for yourself. In fact, it's so who you are that if someone said you weren't, you would be ready to box.

Your self-image is how you see yourself.

It's who you are for yourself. It is not the roles you play or the masks you wear. It's what makes you choose the roles and the masks. It's that with which you so identify your sense of self that you will trash your relationships, choke when it comes to taking action on your dreams, and do things that directly undermine your money.

Your self-image was created in a moment of crisis when life broke your heart.

It was formulated based on what you saw your momma or daddy do (or the equivalent in your life), or the exact opposite of what you saw in your environment when you were growing up.

But here's the rub: your self-image has worked for you.

It has saved your ass on many a day. It actually works. Think about how many times you have been appreciated for being "nice" or acknowledged for being a "go-getter." Remember all the respect you heard in the voices of your peers or leaders when your "hard work" had saved your company millions of dollars? Let yourself feel the warmth in your chest remembering when your children gave you a birthday card that said you are the World's Greatest Mom. Hell, you may want to cry right now just remembering how whole, appreciated, and yes, loved, you felt in those moments.

But if you start to add up all you have had to do to get those moments— working late, getting up early, dropping out of college to be a mom, sacrificing your career to be a good wife, incurring debt to help out your mom, going it alone, working three jobs instead of asking for help, etc.—you begin to see the cost of your self-image.

You will never out earn your self-image, even if it's positive, because your self-image is rooted in survival. Survival can only operate in a condition of crisis. The moment your self-image is threatened, your survival strategies kick in and you start doing you—in overdrive.

It's like if a mother thinks someone has violated her baby girl—even if it's not true—her self-image as "mother" kicks in and she breaks. For some moms, when they find out their child has been hurt and they know who did it—they black out, wake up bloody, and someone is lying in chalk on the sidewalk.

Self-Worth Blueprint Process™

Your relationship with yourself determines your destiny. It will determine how much money you attract and the ease with which you receive it. This one relationship will determine how you run your business and how you impact the important people in your life. It drastically shapes your love life and even your dress size. How much is your relationship with yourself costing you? Your net worth is directly connected to your self-worth.

Self-Worth #1 Secret:
Your Actions Are a Direct Correlate of Who You Are for Yourself

Step 1. The 1+1+1=3 Formula

The way you discern your Self-Worth Blueprint is to reason it out backwards.

State 1 (how you see yourself) + 1 (how life feels/appears as if) + 1 (survival strategy).

Example: Second rate + have something to prove + being defensive/curt, aggressive talk

Step 2. State a moment or incident when life broke your heart:

Example: Life broke-my-heart moment: Momma cut my hair off

Step 3. When life broke your heart, what did you decide about yourself, others, and life?

Say it in a statement as YOUR SENTENCE like a judge in a courtroom would sentence you to jail.

Example. Life broke-my-heart moment: Momma cut my hair off and I decided the following:

 a. Yourself: "I am stupid" *(because I didn't move)*

 b. Others: "People are against me" *(aka Momma doesn't love me)*

 c. Life: "Life is dangerous" *(took to the streets)*

a. Yourself

b. Other(s)

c. Life

Step 4. State what you say to yourself when you fail, miss the mark, feel threatened or betrayed.

Example: "Who's gonna believe me? I'm nobody." "Nobody wants me." Or, "I don't deserve it." Or "I'm a piece of shit."

Step 5. Ask yourself this question: What kind of person could even think that thought?

Example: "I'm stupid + people are against me + life is dangerous + I'm a piece of shit" = somebody who has no value, no say, no power; someone worthless.

Step 6. Do the Math

1 (how you see yourself) + 1 (how life feels/appears) +1 (survival strategy) = self-worth blueprint

Example: stupid + people are against me + life is dangerous/take to the streets = worthless

MY SELF-WORTH BLUEPRINT = I am worthless

1+

1+

1+

= 3: My self-worth blueprint is:

I am

Step 7. Now help your brain connect how this decision has impacted your life, your performance, and your business. List all the actions you have taken that correlate to your Self-Worth Blueprint for all three steps:

Example:

I am stupid/correlated action = get four degrees

Momma doesn't love me/correlated action = leave home

Life is dangerous/correlated action = live on the streets, etc.

Correlated Actions to Your Self-Worth Blueprint:

CHAPTER 5
SELF-ESTEEM MONEY VS.
SELF-WORTH MONEY

"Are you okay? I am so sorry for you."

I was standing in the mailroom at the university where I had been teaching for seven years. One of my colleagues was comforting me; I didn't know why.

"Hi, Meg. What are you talking about?"

"Oh my God. You don't know."

"Know what?"

"The faculty. They voted against you for tenure. Everyone is talking about it. I am so sorry."

I stopped breathing. A rush of blood filled my ears. Everything sounded like I was under water. She was still talking, but I couldn't hear her. I just walked out of the mailroom and directly to the dean's office.

I walked in without knocking.

"Is it true?"

"Close the door."

"Is it true?"

My dean scurried around me and closed the door. He was a little man with a big heart. Slight in frame, but one of my biggest advocates in a racist department.

"Partially. It was a split vote, with 11 against you and 6 in your favor."

"Dean, that's not a split vote. That's a defeat."

"It doesn't matter. I'll write a letter recommending you. The provost has the final say. The faculty vote is not a determining factor."

"But why?" I could feel the shock wearing off and my blood starting to thaw out. It had been running cold since the mailroom.

"The discussion centered around your publications. They feel that because your publications are in popular magazines and journals instead of academic ones, you do not warrant tenure status."

"But, Dean, you all told me to be different. Bring fresh ideas. Engage the community. How can being published in Glamour Magazine or winning a Black Tony Award make me ineligible for tenure? I'm a performative scholar! That is what I do."

"I know. I know. It's going to be okay. Like I said, I will write you a strong letter, and the provost has vision. He values what you are bringing to this university and the students. You are a valued member of this faculty …"

I stopped listening and walked out. I quietly shut the door behind me and walked out of the building. My body felt like glass. I felt like if I moved too quickly I would shatter into millions of tiny shards.

Once I felt the cool air hit my face, I broke. I sobbed as I walked across campus. Sobbing.

Then, I prayed.

I have a personal relationship with God. I see God as a Black Man who just got out of prison. He is midnight black, ripped/torn. You can tell this brother has been on the yard. Bald. With an attitude problem. I love that Old Testament God with all the smitin' and the smotin'. I love that shit. Given my background, I want a protective God. I needed a God I could talk to, like the Brothers who looked out for me back in Baltimore. I also needed a God who would cut a nigga for fuckin' with me.

So don't judge. God meets us where we are, and I met God in the club.

So, as I was weeping and walking, I started talking to God. It sounded a bit like this:

"God, what the fuck?" You sent me to white schools. I excel in everything. You bring me to Texas—of all places! I raise my own money, fund my own projects, and get great student evaluations. I work harder than the rest of the faculty and serve on twice as many boards as my peers. How could this happen? I did everything right, Lord. I thought they were my friends. How could they do this to me? They know that if I don't get tenure, my academic

career is over. And this after 13 years of schoolin'? God, what did I do wrong? Why do I always fuck up shit?"

I could hear Momma's words coming out of my mouth as I whipped my own back and ass.

"You're so stupid."

"You're such a fuck-up."

"Who do you think you are?"

"You ain't shit."

And my body began to shake. My throat contracted. I felt the exact same way when Momma said, "Get your sorry ass out of my house!" It had been decades, but it felt like it was happening all over again. In my body, there are memories. I felt the same way I did when I was tumbling down the three-step stoop that Baltimore is known for: helpless, thrown away, in danger, and blamed.

I sat down on a bench near the library. And that's when it happened.

I got into an existential street fight with myself. It was a bloody, bare-knuckled brawl. It sounded like this:

Venus, stop it! Just stop.

They don't give a fuck about you.

Their actions have shown you this.

They don't want you.

Stop trying to make people want you.

They don't want you, and Momma didn't want you.

They don't love you, and Momma didn't love you.

OK!

Nanna loves you. God loves you.

Fucked up as you are, I love you, Venus.

Damaged. Broken. Weak. Stupid. Ugly. It's okay. I love you.

Please stop trying to make others want you.

I want you. You matter to me.

I will never leave you. I will not put you out. I will never betray you.

Please stop trying to make people want to keep you.

I want you.

I love you, Venus. I'm so sorry.

I love you.

Now let's go find other people who will love you too.

Within a week I had my first free talk with a group of white male CEOs with companies bringing in at least $55 million annually.

It was in this room on this day that I realized the difference between "self-esteem money" and "self-worth money."

Let's define our terms.

Self-esteem money is based on a psychological term—self-esteem. I define self-esteem as: an internal evaluation of one's self based on one's feelings, thoughts, and even lived experienced.

Self-worth money is not based on an internal evaluation. It's rooted in *valuation*. Valuation is a finance term. It simply means: an external assessment of an asset to a community, group or market.

SELF-ESTEEM MONEY	What you would pay based on how you feel about yourself, rooted in your past experiences.
SELF-WORTH MONEY	What others will handsomely and gladly pay based on the inherent value and intrinsic worth you naturally bring.

Question: have you positioned yourself as an "asset" to a community, group or market?

If you have not, you are being paid EXACTLY what you think you are worth based on your feelings, thoughts and beliefs about yourself. Money never lies. If you want to know how you feel about yourself, check your bank account. In fact, check your savings.

So the game here is to shift from self-esteem money, that will always be up and down—because your performance will be rooted in your feelings—to self-worth money, which is limitless potential rooted in the inherent value and intrinsic worth you naturally bring to life.

But how?

By identifying your Million Dollar Moneymaker™. Your Million Dollar Moneymaker™ is not your skill, gifts, talents. It's not your work ethic or your charisma. It's not credentials or your certifications. You have something

VERY special that you have never identified let alone monetized because as a Black Women you have been socially rewarded for "working hard."

So you rely on your skills, your brain, beauty, or your personality to make money. And it has worked. But it will not make you a millionaire.

Why?

Because every way you know how to make money is rooted in survival. Your survival strategies—right down to the profession you have chosen, the school you attended, the car you drive and even the clothes you wear—are the basis of your self-esteem money.

Self-worth money has NOTHING to do with you.

You will not locate your Million Dollar Moneymaker™ in your skillset, your gifts, or your academic accomplishments. It is located in the last place you will look. Your Million Dollar Moneymaker™ is not located in your fame or your brain. It's located in your pain. Where life broke your heart.

So let's go there.

Million-Dollar Moneymaker™ Formula:
Identifying YOUR Inherent Value and Intrinsic Worth!

Take the answers from a, b, and c from Step 3 of the **Self-Worth Blueprint Process™** in Chapter 4, fill in the blanks below, and then answer the questions as many times as you need to:

1. When life broke my heart, I decided about myself. (Step 3, statement a)

a. How did you react when you decided _____?

(Pour out all the emotions and negativity here.)

b. What did '_____' teach me?

Example: What did people are against me teach me?

To stand for myself, to listen to me, to value me, to put myself around people who I feel good about myself around, to love others for no reason because I know what it's like to feel that nobody loves you.

c. What was the blessing that came out of '_____' that NEVER would have happened otherwise?

Example: I would NEVER have built communities of love and acceptance. Everywhere I go, people feel like they are loved and belong because of me. I would NEVER have created the WE MATTER Movement for Black Women in Business if I didn't understand at a core level how hurtful it is to not have a home when it's you against the world.

2. When life broke my heart, I decided about myself. (Step 3, statement b)

a. How did you react when you decided _____?

(Pour out all the emotions and negativity here.)

b. What did '_____' teach me?

Example: What did 'stupid' teach me?

Answer: Perseverance, determination, tenacity, figuring out solutions, attention to detail, tending to things meticulously, etc.

c. What was the blessing that came out of '_____' that NEVER would have happened otherwise?

Example: If I had not decided I was stupid, I would NEVER have stayed in school. I wouldn't have four degrees, I would not have gone to Stanford University, and I would not have broken the generational lack of education curse on my family. Because of me, my nieces and nephew finished school.

3. When life broke my heart, I decided about myself. (Step 3, statement c)

a. How did you react when you decided _____?

(Pour out all the emotions and negativity here.)

b. What did '_____' teach me?

Example: What did life is dangerous teach me? To discern, to really pay attention to people's actions matching their words, to pay attention to where a person is coming from, to hear what people are not saying, to listen, to be resourceful, to make community EVERYWHERE I go, to watch out for my people, to be loyal, to tell the truth, be real, to walk my talk, and bring my whole self to the game of survival—or die.

c. What was the blessing that came out of '_____' that NEVER would have happened otherwise?

> *Example: I would NEVER have had the confidence to start my own business rooted in my lived experience. Because I come from 'life is dangerous,' I created a business so that Black Women are safe and can be free. I provide a safe place and space for sisters to heal, and I would NEVER have done that if I had not learned what I learned from my decision that life is dangerous.*

4. YOUR INHERENT VALUE ... Emotionally Moving Mechanisms™

Go back through all three questions, specifically your answers to question letter "B" and pull out the 3 to 7 most moving and useful mechanisms that life taught you.

Example: My intrinsic value that only I can bring:
1. Hearing what people are not saying.
2. Loving people for no reason.
3. Tending to people's spirit with tender tenacity.
4. Meticulous care for their hearts.
5. Tell the truth.
6. Be real.
7. Walk my talk.

1. _____

2. _____

3. _____

4. _____

5. _____

6. _____

7. _____

Your Million-Dollar Moneymaker™ is your survival mechanism(s,) seduced and harnessed to work for you instead of against you, in SERVICE of humanity. It's not one thing. It's a mixture of survival mechanisms you purposefully employ to change the world.

5. YOUR INTRINSIC WORTH ... Forged in Fire Fodder™

Read back through what you wrote and make a list of all the aspects of your character that was forged in fire. This is not who you want to be; this is really who you have always been but did not put a value on it. It may even sound negative. It is what walks in the room when you come in. It is your heart, your very nature to do and give. This is YOUR worth.

Example: The character traits that were forged in fire (my inherent worth that walks in the room with me) are:

1. *Inspiration*
2. *Compassion*
3. *Empathy*
4. *Authenticity*
5. *Personal integrity*
6. *Loyalty*
7. *Rigor*
8. *Courage*
9. *Clarity*
10. *Confidence*
11. *Intensity*
12. *Ruthlessness*
13. *Resourceful*

14. *Strategic*
15. *Calculating*
16. *Sensitive*
17. *Tenacious*
18. *Never back down*
19. *Find a way or make one*

Your turn.

1. _____

2. _____

3. _____

4. _____

5. _____

6. _____

7. _____

8. _____

9. _____

10. _____

11. _____

12. _____

13. _____

14. _____

15. _____

16. _____

17. _____

18. _____

19. _____

Here is where you will make millions! This is your intrinsic value AND the inherent worth you naturally bring to life! It is not your skills, your talents, or your gifts. It comes from your lived experience and it was forged in fire. It is what YOUR TRIBE has been praying for, and they will pay you top dollar for it through you!! And when they do, you become that sister who can write the check. #bossmovesbaby #welllll #hollaandpreach

CHAPTER 6
BEING ABLE TO WRITE THE CHECK

Somebody has to write the check. Why not have it be you?

Real talk: Black Women in business are the most underfunded group in North America.

Carolyn M. Brown wrote an article for Black Enterprise, which states that women own 30% of all U.S. businesses—9.4 million in total. Nearly half of those businesses (a whopping 14%!) are owned or controlled by Black Women, who generate $52.6 billion in combined revenues and employ 297,500 workers.

http://www.blackenterprise.com/small-business/7-top-grants-or-free-money-for-black-women-entrepreneurs/

Sounds impressive, right?

Yet, she goes on to write, "women entrepreneurs—across the board—are getting the short end of the stick when it comes to obtaining the cash money to start or scale a business."

I agree with her. Capital is the key to fund your dreams. But the traditional ways businesses are funded in the United States are in direct opposition to Black Women's lived experience. Angel investors, venture capitalists, and bank loans for something other than a house or car aren't how most sisters fund their dreams. We will work an extra shift, take on an extra job, and pull from our living expenses or our savings before we will think to pitch an angel investor or compete for a venture capitalist.

For many Black Women, the idea of getting an angel investor specifically for the first round of "asks"—your family and friends—feels "white." Most successful sisters have family and friends who come to us for money. So the idea of getting an angel investor from the people who already know us feels like a fantasy.

When we are told to go get funding from a venture capitalist, it's intimidating. There is an entire education that one needs to master to be in the running to even get seen by a venture capitalist. And unless you have been groomed to speak the language, get in the room, and give a damn near perfect pitch, your chances as a Black Woman who wants to start her business without a business training background are so small, it seems too daunting to even try.

When Black Women try to get small business loans or bank loans, we confront two things: a historical distrust of funding institutions and our credit. Black people don't trust banks. We would rather put our money under our mattress. Banks are institutions that have, historically, fooled us or preyed on our ignorance. Banks have turned us down for car loans, home loans, and student loans. For a number of us, trying to get a bank loan may mean extremely high interest rates because we are perceived as not a good risk.

It's a lot of hassle.

The reason we are not considered a good credit risk is because, generally speaking, sisters have fucked up credit. And to be fair, her low credit score may very well be a function of her trying to help family members. A lot of times, Black Women are asked to put utilities in "their name" to help out a family member who needs to keep their lights on.

- Or we will co-sign on a car note to help out our brother who just got out of jail and needs to go to work.
- Or you put your house up for bail—and when your uncle skips town, you lose the house and your credit is in the toilet.
- Or you file for bankruptcy because you have been living on credit cards to be both momma and daddy when your man left you without any provision to take care of your four babies.

My point is this: there are invisible societal barriers to getting capital in ways that White people have historically been able to access. There are also personal and cultural behavioral practices that keep Black Women struggling

to pay for the cost of doing business. Those same systemic and behavioral practices also make some of us feel like we have to stay at that "good" job to get that corporate welfare check.

I say—fuck that.

Why not create your own capital?

Why not learn how to bring in money with the skills you are already using to make other people rich? When you learn how to monetize, to bring in money using your skills and your story, you become your own bank. And when you do, you can write the check with a whole lot of zeros.

So in order for you to write the check, you have to learn how to bring in what I call, "New Money." You need "new money" to have "seed money" to make the "big money"—on your own terms.

Let me explain.

My Self-Worth Blueprint says that I am worthless. As someone whose self-image is worthless, I would either over-achieve or attract people, jobs, and situations that treated me like a piece shit. So my self-esteem was in the toilet. My self-esteem determined how much money I would allow myself to make.

Real talk: education and the Arts are two of the lowest paying professions in our economy and that's exactly where I went.

My self-esteem money was my job as a professor. The top five skills I had from this career were:

1. Teaching
2. Speaking
3. Writing
4. Listening
5. Inspiring others

These were all survival strategies that got me out off the streets and a "good education." But as a professor, I was only bringing in $47K (after taxes) on a 9-month contract. So to cover my summers I had to teach or get a gig as a performing artist. When my faculty voted against me, I became committed to leaving my day job. The first thing I had to do was take the same skill set I was using as a professor and use it to bring in "new money" for myself.

So I started teaching at youth centers. Same skill; different group.

I started to speak at local community colleges. Same skill; different universities.

I started writing proposals for a medical office. Same skill; different client.

I started to listen deeply for unspoken hurts in groups. Same skill; different situation.

I started sharing my story of the streets to Stanford. Same skill; different audiences.

These 5 skills are the basis of my multimillion-dollar company.

So don't sleep. Your skills are very bankable for "new money." I use them to fund the dream. So can you.

Let's start with your top skills, who needs that and where to find them!

New Money Now Blueprint Process™

Step 1. Top 5 Skills

List the five skills you KNOW you can do that have made you money in the past and that you are MASTERFUL in doing. For example, my top five skills are teaching, speaking, listening, writing, and inspiring others.

Notice how basic and applicable these skills are to various industries. They are not linked to my passion. They have NOTHING to do with my story or my dream business. They are elementary building blocks that were required for me to teach.

1. _____

2. _____

3. _____

4. _____

5. _____

Step 2. Discern Who NEEDS That

Now, for each of the five skills you listed above, write out WHY other people need this skill. Forget it's you for a moment, and sincerely write down why another person would need that skill. What will that skill provide or protect them from?

By each skill write down the communities, groups, and organizations that NEED that skill AND can pay you.

1. _____

I could be paid by:

2. _____

I could be paid by:

3. _____

I could be paid by:

4. _____

I could be paid by:

5. _____

I could be paid by:

Now look back over the five and write down the biggest problem you solve and the biggest benefit you provide with that skill for those organizations. Write it out first and then distill it to two simple statements.

Example:

Skill: *My ability to teach people who react when they feel talked down to, belittled, or judged will save their marriages, help them keep their jobs, and empower them to create their lives instead of reacting to life's challenges.*

Benefits: *Saved marriage and keep job*

Biggest Problem I solve: *Create your response instead of reacting to life's challenges.*

Skill 1.

Benefits:

Big Problem I solve:

Skill 2.

Benefits:

Big Problem I solve:

Skill 3.

Benefits:

Big Problem I solve:

Skill 4.

Benefits:

Big Problem I solve:

Skill 5.

Benefits:

Big Problem I solve:

Step 3. Identify Your "Buyers' Market"

Go back to the communities, groups, and organizations that you listed and discern, figure out, or simply count which industry has the most names by it. This industry will be your starting point. Make sure it's a buyer's market, meaning you do not have to convince someone to buy. You are purposefully on the hunt for industries with people who are actively LOOKING to buy.

For example, people in nonprofits, education, or the arts are NOT looking to buy. But a woman looking for a wedding dress? Oh, she is looking to buy! Here are some "buyer's markets":

Bridal

Entrepreneurs

Seasonal Photography

Weight-loss

Resorts and Spas

Hospitals

Wellness Clinics

Food Industry

Child Care

Fashion Industry

Landscaping

Beauty Industry

Administrative Support

Network Marketing Groups

CEO Roundtables

Securing High Education Industry

College Prep

Travel

Home Maintenance & Cleaning

Real Estate

Professional Organizers
Animal Care & Grooming
Camping/Hiking/Trekking
Extreme Sports
Time Management Industry
Janitorial
Financial
Florists

Copywriters
Tech and Web Design
Social Media
Project Management
Arts and Crafts Industry
Bargain Shopping Industry
Outlet Mall Excursions

Step 4: Match Your Skill to ONE Industry's Need

Looking at all five skills, decide which industry is the best and most lucrative match for your skills. Pick the skill with the most IMMEDIATE monetary potential. Do not pick the one that YOU like the best or that is similar to what you want your passion to be.

You have to crawl before you walk.

And it takes this kind of basic truth-telling and due diligence to train yourself to be a successful entrepreneur instead of a struggling one. Bringing in "new money" is NOT about how you feel. This is about who will pay you to do something that is easy for you to do and that brings in new money so you have the working capital to build a scalable and saleable business.

This doesn't mean you hate the skill. I like writing more than I like speaking. But speaking was easier for me to get into and quicker to monetize than writing. So I went with speaking first because I could get in due to my connections with theatres and youth centers. I could gig. Make sense?

Most IMMEDIATE bankable skill:

Buyer's industry that NEEDS that skill:

Keep in mind that because of the history of hurts we have inherited as Black Women, we have more credibility with ourselves in making other people rich with our genius, than of making money for ourselves. When you take on the actions to master bringing in new money for your own dreams (instead of slavin on that corporate plantation) you are breaking the Black Woman's generational curse of being the workhorse, cash cow, beast of burden, or scapegoat for somebody else's dream.

Simply put: your dreams need to be financed.

Is it starting to make sense? Can you see how easy this can be—starting exactly where you are to bring in cash money? But there is one thing we must tend to if you are to take action on any of this: realizing in your very soul that money is a heart condition.

PART 3: SPIRIT

CHAPTER 7
MONEY IS A HEART CONDITION

It's easier to make a million dollars than it is to make your first hundred thousand.

Why?

Because the first hundred thousand is a state change. Like going from water to ice, a simmer to a boil. Or going from cocaine to crack. It's a state change. Due to the history of hurts we have inherited regarding money, we relate to ourselves either as commodities or as animals.

(I know it's harsh. But keep reading. It will make sense in a minute.)

A commodity can be bought or sold, based on the service provided. An animal (e.g., horse, mule, goat, cow) is used and reused until it is used up—exhausted, depleted, useless once it's past its prime. So while Black Women are no longer wet-nursing a mistress' child or hauling bales of cotton on their back, the behaviors and sense of self as a workhorse, cash cow, beast of burden, or scapegoat have been passed down to us.

We all know (or maybe you are one yourself) sisters who feel like if they don't work hard, they didn't earn it.

We as Black Women have been trained to believe that working hard is the key to economic success.

Real talk: Rich people don't work hard.

In fact, rich people don't work at all. They have other people work on their behalf. Rich people don't "do."

Sis, we have been taught that in order to make money, we have to "do" something. Going to school is a "doing." Getting good grades is a "doing." Getting a "good job" is a doing. "Working" at your job is a "doing." Getting promoted is a "doing." Do, do, do, do, and some more do, is what Black Women have been socially positioned and socially rewarded for.

Except … if you put a dollar amount on all the "doing" you have done to "get ahead," you will see that the money you have made is minuscule compared to the amount of effort you have exerted.

Working hard will keep you broke … and broken.

I know, sis. I know you were taught to "work hard" if you want to get ahead in life. So were our ancestors. In fact, they were reared to work hard or get beaten. I know you were yelled at, shamed, or got your ass beat for not working hard enough. In fact, if we tell the truth about it, "working hard" started early and followed you around for the rest of your life like a rabid dog stalking you, always there ready to pounce.

But money is not a function of effort. If it were, you would be a billionaire by now.

> *This is going to sound radical, so please breathe through this with me.*
> *Take a deep breath in.*
> *Hold it.*
> *Exhale.*
> *Okay.*
> *Sweet.*
> *Keep reading.*

Money cannot be made.

> *Stay with me.*

It's not a tangible artifact, so how could it be "made"?

You can't touch money.

You can touch the sign, the signifier that stands in for money—be it cowrie shells, gold bars, or zeros and dashes on a screen—but you can't physically handle this phenomenon called "money."

Money is actually the exchange of energy.

Think of it as currency. Like water and electricity, money is fluid. It moves and conforms to the various conduits required to channel currency into material form. For slave masters, the conduit to creating the labor force to flourish the antebellum South's economy was Black Women's bodies. They used our wombs and our physical exertion (aka energy) to make themselves rich.

So if you want to be a Black Woman Millionaire, you are going to have to truly transform your entire relationship to money—from effort to energy.

You are going to have to access your own conduit, and because of our singular experience of being descendants of enslaved African Women, the conduit you are going to have to access is your heart. Because money is energy and not effort, you need a clear channel to have money show up in material form in your bank account. Just like wires that run through your walls, and when you flip the switch in your living room, the space is illuminated, your heart has to be clear so that Spirit can move through you to manifest your dreams.

Money cannot manifest through a congested heart.

Money cannot manifest through a congested heart.

The reason money can't manifest through a congested heart is because you have turned against you. In your heart of hearts, you blame yourself for all the bad things that happened to you. You have put yourself in an emotional prison, on an energetic chain-gang for crimes done to you, or that you have done that you regret, resent, or are ashamed of.

So if you want to shift from "effort to energy" you have to become as emotionally attentive to yourself as you would a lover. Instead of stuffing it or working on top of your hurts, you need to pinpoint them you as soon as you feel disempowered so you can tend to your hurt heart.

God's conduit to show up in your life as your dreams manifest is through your heart. So you have to heal your own broken heartedness—which shows up in your money as being "broke"—so you can receive your cultural and divine inheritance.

Let's go … within.

Hurt to Healed Scale™

Take a moment and just think about the different stages you go through, starting at "I want to MURDER" to "Life is MAGNIFICENT." Beneath the anger is a level of hurt. Name the hurt.

Then, build your scale from 0–10ish: 0 being pure numbness and 10 being fully feeling, vibrant, alive.

Here is my example:

Scale	Emotion	My Experience
15	Peace	one with God
14	Giddy	present to love
13	Bliss	grateful
12	Joyful	appreciated and respected
11	Happy	acknowledged
10	Amused	engaged
9	Interested	feeling heard
8	Bored	turned my back on them
7	Detached	turned their backs on me
6	Rage	blamed unjustly
5	Angry	lied on
4	Pissed	challenged
3	Annoyed	contradicted
2	Agitated	ignored
1	Insulted	diminished
0	Numb	dissociate

Please note: Create YOUR own scale. You can't copy mine. You have to look in your real life to see how you go from 0 to 60 when you feel hurt—even just a little. This scale will be your salvation as you learn to manifest. You have to be able to locate yourself on your scale so you can move up or down.

The good news is that once you know where you are and how you are triggered, it is easier to move up your scale to the healing spaces instead of staying stuck in the lower ones. None of the spaces are bad. And they all work.

But money and happiness are at the top. So create your authentic "Hurt to Healed" scale so you can manifest!

Scale	Emotion	My Experience
15		
14		
13		
12		
11		
10		
9		
8		
7		
6		
5		
4		
3		
2		
1		
0	Numb	dissociate

CHAPTER 8
"MAKING MONEY" VS.
MANIFESTING MILLIONS

When I was living on the streets, I made money by picking up trash, scrubbing floors, and selling shoes. It wasn't enough. It was never enough. So I started hanging out with the strippers.

The strippers needed someone they could trust to pick up the (mostly) one-dollar bills off the floor, or indicate to them what part of the room they needed to work to make more money. The more helpful I was, the bigger the cut. I would watch to see who drove up in a nice car and let the ladies know. They praised me, looked out for me, and made me feel like I was part of a family.

So of course, as an adult the way I made money was by being "helpful" or "useful."

I became a professor. I over gave. I overcommitted. I over prepared. My survival strategy of "be useful so they don't throw you out" was running my money. But in education, the more you give, the more they expect—without pay. It's considered "service" to be on committees and be dissertation chairmen.

The more useful I became, the more I was used. And used up.

I was putting in 60–70 hours a week due to the grading load from teaching five classes that each required two term papers, five quizzes, a midterm, a

final, and three trips. It was exhausting. But I didn't want to be thrown out, and I needed the money.

Take a moment and look at how you "make money."

Are you doing things in your current job or business that you are not being paid to do? If so, ask yourself these three questions:

1. Why am I doing this?
2. When did I start this behavior?
3. What do I get out of doing this, or what do I avoid by doing this?

When I confronted the fact that I was still being the little Black girl whose momma put her out, I realized that I was "making money" to avoid being thrown away, and that part of me needed to be healed.

The more I healed my heart, the less I had to work and the quicker money came to me.

Most of us "make money" because we crave certainty, security, stability, and acknowledgement. Some of us "make money" to be needed, to be in charge, to dominate, or to never feel powerless. But each of these reasons are only survival strategies created in a moment of crisis when life broke your heart. So instead of focusing on how to make mo' money, I focus on healing our hearts.

When I unpack the phrase "healing your heart," what I am truly pointing to is you being authentic about how your survival strategies are running the show. When you are hurt, your survival takes over to protect you. If one of your wounds is "I'm a throw away, nobody wants me" then your survival strategy (the behavior that serves as the "fix it" to the wound) will be to make yourself indispensable—at all costs. So you have to go to the source of the behaviors and drill down to what is really driving you.

So let's get to drilling with these seven questions:

SEVEN QUESTIONS TO HEALING YOUR HEART

1. How do you "make money?"

2. What survival strategy is running your money the most?

3. What are all the ways you do shit for free? _(No shame—be proud.)_

4. Ask yourself: Why am I doing this?

5. When did I start this behavior?

6. What do I get out of doing this, or what do I avoid by doing this?

7. What would I have to confront or let go of in order to stop working hard?

Profound, huh? These seven questions reveal so much truth so quickly it's pretty incredible. Now that you can see where you started to "make money" we have enough groundwork to move into manifesting by tending to the one thing that counts in allowing money to come to you—the energetic.

CHAPTER 9
THE RIGHT ACTION IN THE WRONG
ENERGETIC KILLS YOUR CASH

Take a moment. Think back on one specific incident where you did your absolute very best.

You worked hard.

You prepared.

You put the time in.

You even dressed to impress.

You put your best foot forward.

Only to have the door shut right in your face.

But you tried again.

You put in the correction.

You pumped yourself up in the mirror.

You prayed.

You did affirmations.

You meditated.

You focused.

You fasted.

You. Did. Everything. Right.

And you failed.

You didn't get the job.
You didn't get the raise.
You didn't get the sale.
You didn't get the guy.
You didn't get the girl.
You didn't get the award.
You didn't get the pardon.
You didn't get skinnier.
You didn't get rich.
You didn't get the book deal.
You didn't get the loan.
You didn't get the degree.
You didn't get married.
You didn't get the terms you wanted for the divorce.
You didn't get the house.
You didn't get the car.
You didn't get pregnant.
You didn't get the laugh.

Yes, you really did do everything right. More than once. And …
 … you didn't get what you really wanted when it mattered most
 to you.

So you did what Black Women do:
 You made it work.

But now, you have an attitude.
Now you are resentful.
Doubtful.
You have become subtly, quietly resigned.
Your "come from" used to be hope.
Now it's "we'll see."
You start to believe—down to your bones—that nothing you do is right.
Or that the world is against you.
Or that you are flawed on some fundamental level.

Now life, God, and man have to prove to you that you can have anything you truly want.

But with each disappointment, each failure, each missed mark, you stop dreaming, you stop believing, and you stop hoping more and more, until all that's left of the little Black Girl inside of you is a ghost with her hands over her mouth. She keeps them there so she doesn't scream until your lungs bleed or sob until your heart breaks.

Shhhhh … sis.

It's okay.

I understand.

And I want to tell you something that, if you let it in, will change your life.

Would that be okay?

(Take your time. I will wait for you.)

You ready?

Okay. Here it is:

The only thing missing from all you have done is one thing no one ever told you about.

The one thing you didn't know—and couldn't have known—was to tend to the "energetic."

When you want something to manifest, there are two worlds at play: the action and the energetic.

Sis, you were focusing on what to do; you didn't tend to the energetic.

Think of the energetic as your emotional atmosphere or your "come from."

Let me explain.

Think about a time when you really wanted to bring in some cash. And you started doing all the right things to get the money—except you were desperate. You didn't necessarily look desperate. But in your heart of hearts, you were coming from a space of need and lack.

That energetic space of "need and lack" was the emotional atmosphere.

It was your "come from." It was the invisible spiritual container from which you were taking all the right actions. Your actions were clean, but the container was dirty.

Energetics: Creating An Emotional Atmosphere
7-Step System™

Check out if your "come from" is an automatic "no" to life. Or do you tend to hedge your bets?

Nine times out of ten your default Emotional Atmosphere is something to the effect of, "I can't have what I really want," or, "I don't trust myself," respectively.

If your emotional atmosphere is that you have to work hard, overcome, prove it or make it, you will manifest that reality.

The way you create an emotional atmosphere is simple:

1. Tell the truth about what you don't want or like

2. State what you want

3. Let yourself feel it already done

4. Give gratitude for it being done

5. Give it over to God as if it's already done

6. Take actions consistent with it being done—with no evidence

7. Walk it like it's already done until it manifests

That's it.

The challenge is walking it like it's done when your default atmosphere is still raging.

So part of what you will have to do to shift is to set up your life for where you are going, not where you are. For example, if you say you want to be a 7-figure sister and you are currently earning 5 figures, you will have to put yourself around 6- and 7-figure people until you feel, believe, and know you are a 7-figure earner, and look for opportunities to prove yourself right about it— BEFORE you have a 7-figure income.

The more you can prove yourself right, the faster you will manifest whatever you are creating.

But you need an emotional atmosphere to house the actions. If you are taking actions to break 6- or 7-figures but you behave and have an attitude of "I don't deserve," "I don't know what I am doing," or "This is some bullshit," your actions will not produce the desired result. You will be doing ALL the right actions in the wrong energetic.

In order for your actions to quantum leap you to your destiny, the emotional atmosphere must be created, consistently nurtured, and tended to until the outcome manifests like the NATURAL COURSE OF EVENTS. Not as a miracle, but as an "of course." When a flower blooms, it's an "of course the flower will bloom," because it's the very nature of the flower to do so.

You are an expression of God, endowed with the same creative power as Spirit in all its iterations.

You can create anytime you want to do so. The trick is to KNOW, not believe or have faith. When you know, like you KNOW the Sun will rise in the east and set in the west, faith and belief are nonexistent. #dropthemic

PART 4: STRATEGY

CHAPTER 10
LEAN INTO THE P.A.I.N.
PLAUSIBLE ALTERNATIVE INTERPRETATION NOW

When I was 12 years old, I had a Jheri curl. It was a popular hairstyle of the '80s. I don't remember the circumstance around it, but I do remember coming home with my new hairdo and feeling pretty. I walk into the house and it's way too quiet.

I see Momma.

Our eyes meet.

She is mad. I don't know if she is high. I don't know if she just got into a fight with her man and whipped his ass (Momma didn't play) or he got the drop on her—this time. I don't know if she had lost money or her check was late. I didn't know why, but I can feel the rage rolling off her like licks of fire.

And now, that rage was directed at me.

My body started to shake. I remember her saying mean things and pushing me up the stairs. I was terrified. I didn't say anything. She shoved me down the hall and pushed me down on the bed. I didn't move. I just sat there. Shaking. She came back into the bedroom with a pair of scissors. She grabbed a fistful of my hair and painfully pulled my head back until my neck ached.

I said nothing.

Within seconds, I heard the scissors snap. My neck stopped hurting. Until she grabbed another fistful of my hair, wrapped it around her knuckles, and

cut. Then I saw it. My hair, long damp curly tresses falling … on my lap. On my shoulders. On the bed.

I said nothing.

She kept grabbing and cutting.

I felt a thick warm liquid slowly roll down the side of my face in a single line. My neck. My brow. She kept cutting.

"Now, no one will look at you," she sneered when she was finished. She pushed my head away and I could feel the cool air on my scalp.

I gingerly raised my shaking fingers to my head and flinched.

She had cut my hair off in uneven patches down to my scalp. And there was blood. I got up slowly and picked up a bandanna. I wrapped my head in it. *(To this day, I feel protected when I cover my head.)* I looked at Momma and said, "Good-bye, Momma, forever."

Dazed. Stunned. I left the house.

I was twelve.

It took me four more years to get out of Momma's house for good, but it all started with that incident. For years I suffered over Momma cutting my hair off. I felt ugly because she told me I was, and stupid because I didn't move. On the streets, bad things happen. And in order for me to survive Momma and the streets, I came up with leaning into the P.A.I.N.

I became masterful at creating **P**lausible **A**lternative **I**nterpretation **N**ow.

Being able to lean into the P.A.I.N. is how I got off the streets and into an empowered life. It's also how I have been able to keep going and create a multimillion-dollar business when things would go sideways. It's how I stay in the game when my survival strategies kick in and try to take me out. If you don't master leaning into the P.A.I.N. when life breaks your heart, the history of hurts you have inherited will eat you alive.

Locating Your Own Innocence Process™
Stop BEING 'broke' by tending to your heart space

Step 1. Incidents: Tell the truth/Scream it from the rooftops

Go back through your life in 5 year increments and document every place where life broke your heart.

Step 2. Open Wound

Pick the incident that still stings or hurts the most.

Step 3. Just the Facts

Write down in exact detail what happened followed by how did you feel.

Step 4. Your (Jail) Sentence

What did you say to yourself about yourself (your head).

Step 5. Alchemy

Locate your own innocence (your heart).

Step 6. (W)Righting History – Play with the past, making room for the future

Go back through each incident and rewrite your story with your innocence front and center.

Step 7. Allow

Review your lifeline and allow yourself to be moved to tears by how incredibly brave, generous, courageous, genius, and resourceful you are. If you can allow yourself to see your own innocence, you begin to make room in your heart to receive love, wealth, peace, and sheer joy.

The key to healing your heart is locating your own innocence. You have to get on your side. I am not asking you to lie or front. I am asking you to be brave enough to look at the times when life broke your heart and tend to the little girl inside.

Love on her. Defend her. Protect her. Celebrate her. Life tried to kill her, but she didn't die. She nursed you to life and has been carrying you as an adult. Bath her in love. Baptize her in tenderness, grace, mercy. Go on a hunt for her innocence and let yourself feel how magnificent she is and how magnificent you are.

You, my beloved sister in success, are absolutely exquisite. Open your heart to you. And when you do, you open up the space for spirit to bless you indeed, enlarge your territory, and manifest … through your open, receptive heart.

As back up, here is another exercise that will restore your power and get you back in the game when you get stuck in your own rightness, righteousness, or survival.

Your Truth/The Truth/A Truth™

1. Pick one of the incidents from your life that still hurts or haunts you.

2. Write down what happened. Tell the truth.

3. Now write down an alternate interpretation of your truth that is just as valid as what you truly believe.

4. Write down another alternate interpretation of your truth that is zany—just as valid but a little off the wall.

5. Write down another alternative interpretation of your truth that could be true—if you knew facts you don't know right now or never considered.

Keep doing this exercise until you can see that "your truth" is not "the truth" but "a truth."

The point with this exercise is to see that there is more than one way to interpret the same actions. Did Momma "cut my hair off" or did Momma "give me a short haircut"? Which interpretation of the exact same action is true? Well, both ... and neither.

My truth is not "the truth" of Momma's actions. It's "a truth" that's just as valid as any other plausible interpretation I can dream up. The real question is: which interpretation empowers me? Go with an interpretation that

1. You will buy into and
2. Empowers you.

CHAPTER 11
"I CAN'T" TO "HOW CAN I?" ACCESSING MONEY THAT IS ALREADY THERE

Have you ever said, "I can't afford it" before you have even tried? You just see the price tag or hear the cost and opt out. You close the door. You decide it's outside of your price range, and you sigh and go look for something less expensive.

Be honest.

I know I have. Sometimes when I get scared, confronted, or triggered, I still find myself saying, "I can't." So I get it. But here's the truth, sis: The moment you say, "I can't afford it," you kill off all access to Spirit, possibility, and creativity. You have, in that utterance, sentenced yourself to the past. How? By looking to what you did yesterday as the yardstick for what you can do tomorrow. And when you say to yourself, "I can't afford it," you feel poor. Broke. Broken. Less than. Not enough. In that single saying, you evoke an entire history of Black Women as not worthy.

Here's the truth. Unless you are sleeping on the street or living in your momma's basement (and I have done both), you actually can afford it.

Oh boy.

I can feel you inhaling, rolling your eyes, and getting ready to argue me down about all of your bills, obligations, and what you don't have. You are

ready to fight for your limitations. Stay with me. Just listen, okay? Try to keep an open mind about this.

Let me try, all right?

Just hear me out instead of shutting me down because you think I don't know your particular story. You're right. I don't know your story. But I know your Spirit. You are a Black Woman with a destiny. And my job is to get you to see that you are bigger than your bruises. That you are not your past, and money ain't shit.

Look. Let me try again.

Money is the easy part. The healing part is the motherfucker. So please stay

> *Money is the easy part. The healing part is the motherfucker.*

with me with an open mind and heart while I break this shit down so you never have to slave again. Will you please stop throwing shade? Pump the brakes, boo. I am not denying your truth or your lived experience. I am saying—or trying to say—you are blocking your blessing the moment you look at the tangible to decide what you can or can't afford.

You're giving me attitude—with how you turn the page?

Why are you being so obtuse?

Oh, so we doing this, huh?

Fuck it. Let's just go there.

When you say, "I can't afford it," that's you being lazy. Yes, lazy. Yeah, I said it. How do you know you can't afford it? Hmm? Haven't you been able to "afford it" when you wanted something really bad? Or don't you always find a way or make one when your children need you? Or your mom? Or that nigga?

Look, you started this.

I was trying to be nice. You want to start throwing shade energetically at me? I can feel you. Don't think just because you're reading my book that I can't feel you. I already told you: We are spiritual beings having a human experience.

So I can feel when you start resisting truth.

I find it ironic that the moment we begin getting into "I can't afford it," you want to start a fight. Oh, but you did. You did so silently. In your mind. Setting up barricades and barbed wire energetically that you think other people don't see. We don't have to see it. We sense it.

We feel it in the sharp intake of breath or the side stare. People aren't stupid. When you are energetically a "no," it communicates. And you get like this whenever you are called out about taking action that requires money. You are quick to say, "I can't afford it" and start up some shit when somebody questions or challenges you. But the truth is, that's what sisters do when confronted with how we cop out on ourselves and our dreams. You actually can afford it—but you may not want to do what you would have to do to afford it.

Don't fuck with me about this.

You can afford anything you commit to. You already have. Look in your life and you will see that when you want something, you find a way or make one. The only time you "can't afford" something is when it doesn't reinforce your self-image. You will move heaven and earth to see yourself as a "good mom" even if it means underfunding your business. But you do it and you have done it. You've been able to afford it when you needed to look a certain way to have White people think well of you. Oh, oh yeah, I went there! Shit's real. That weave you rockin', those Red Bottoms you're stylin' and profilin' in were once things you couldn't afford. Am I lyin'? Real talk—am I lyin'? Hell nawh! Don't trip. I have done it too, which is why I'm telling you that when you say, "I can't afford it," that's some bullshit.

That's you turning yourself into a victim, and I refuse.

YOU are a Black Woman with a destiny. You are not a punk-ass—and neither were your ancestors. "I can't afford it" means you are not committed or too lazy (or too comfortable) to try. Because the money is already there. You're just looking in the wrong place. You're looking at what you can see; I am looking at what you would have to let go of to dream so Spirit can grow you the fuck up.

Hey, don't back down now! Stay with me. Look, I love you enough to tell you the truth about yourself to your face.

If you want to access money that's already there, the first thing you are going to have to confront is how easily offended you get by truth. And the truth is that each and every time you say, "I can't afford it," you just piss on

every sacrifice our ancestors made for you to have the option to try. And that is not okay with me.

Say you don't want to.

Say it's not something you are committed to.

Say you are not willing to do the fuckin' work. But for the love of God and all things holy, DO NOT say, "I can't afford it!" Especially when you are able-bodied, employed, with a business, and have food as well as shelter.

Your mother's mother didn't say, "I can't afford it." She scrubbed floors.

Your great-grandmother didn't say, "I can't afford it." She sharecropped and picked cotton.

Your African ancestors didn't say, "I can't afford it." They mastered maritime trade—including selling our black asses into slavery on the continent and worldwide. What the hell do you mean when you say, "I can't afford it"?? What? I'm going to tell you exactly what you mean.

When you say, "I can't afford it," you have just succumbed to the emotional, mental, psychological, spiritual, and economic bondage of slavery. The White Man won. Arm chains and leg shackles on your body are completely unnecessary now.

No need.

You just pissed on 400 years of progress.

You just turned yourself back into a slave.

From "I Can't Afford It" to "How Can I?" Accessing Money That's Already There!™

When you or I say, "I can't afford it," what we really mean is, "I don't see how to get the money to pay for this." Black Women, as a group, tend to only count the money we make directly. We count cash or credit cards. We count what we can see, especially money we make through effort. You see a price tag and do a quick mental scan of how many bills you have coming in, what your kids need, and your next pay check and decide you "can't afford it."

Decide has the root word "cide."

Cide comes form the Latin word meaning "killer" or the "act of killing." Think about it. Compound words like genocide, pesticide, and suicide all end with the same root word. "Cide" means to kill off all other possibilities. So the

moment you "decide" you can't afford it, your brain kills of any other alternatives. You literally can't see any other ways to have what you want. Not because you can't have it but because you have killed possibility.

So if you want to turn the tide, simply ask yourself, "If it were possible, how could I...?" and let yourself dream. Start brainstorming. If need be, mastermind with other sisters in success. Write down various ways you could actually afford what before looked impossible. At first you will stumble. But the more you imagine and dream, the more you will start to remember the sister who owes you money or the ex who created a savings account for you. You will start realizing that you have not let people know what you want for your birthday or that 401k you have been sitting on. When you start dreaming, you will see that you could refinance your house—that doesn't mean that you will, but you could.

Then you start to bump up against how unwilling you are to bet on you and trust yourself. You will discover you have an addiction to security or certainty and don't really want the desires of your heart—unless they are risk free, convenient or comfortable. You will confront how full of shit you are about having what you say you want or becoming a Black Woman Millionaire. You will start to see that there is plenty of money around that you "could" access but YOU would have to make requests, trust yourself, bet on you and take risks.

You would have to hustle and let go of your death grip on security. Once you see the multiple ways you could afford it, you have to choose what are you more committed to—being a punk-ass about your dreams or being the author of your life for real for real. You would have to trust yourself, trust life and trust God. You have to accept that money is not a function of your effort but your willingness to let God move through your heart space so you can be the answer to millions of people's prayers.

CHAPTER 12
SURRENDERING TO YOU BEING THE ANSWER TO MILLIONS OF PEOPLE'S PRAYERS

You are God wrapped in flesh.

You are a unique expression of the Divine.

You are perfect. Whole. Complete.

You are the best that has ever been and ever will be.

Just like a wave is an expression of the ocean and a branch is an extension of a tree, or a sunbeam is an outpouring of love from the sun, you are God made manifest.

I know you don't believe me.

I know all you see are your wounds.

Your failures. Your mistakes.

But I invite you, just for a moment, to take the case that everything you have experienced was God preparing you to change the world. What if the pain was the preparation for the call? What if everything you have been ashamed of (i.e., every betrayal, every slap, every rape, every molestation,

every bankruptcy, every foreclosure, every lost child, every affair, every death, every cancer cell, every illness, every put-down—everything) was actually God creating within you a capacity and a compassion for the millions of spirits who need you?

You, my sweet sister in success, are the answer to millions of people's prayers. When you let the pain have purpose, it makes room for your affluence. But there is a caveat. You have to surrender. You can't make the alchemy of pain into purpose happen. You have to let yourself be used for something bigger than you. You have to surrender your rights. You have to surrender your addiction to knowing. You have to shift from "getting" to "letting."

Allowing™ Letting Go

Letting go is your access to letting the abundance, affluence, and ease of the Universe to pour into you. God can't move through you in a crowded head and a heavy heart. Letting go Gives God room to do God.

Who do you need to let go of in your family?

Who do you need to let go of in your professional communities?

Who do you do you need to let go in the arena called friends?

What habits (mental an emotional) do you need to let go of that rob you of your peace and joy?

What actual behaviors (actions) is it time to let go of so you can hear God easily and regularly?

Surrendering

Surrendering is humbling. It is you saying to Spirit, "I am no longer depending on my will power and I give up my attachment to how I thought this was going to look. I trust you Lord and I trust me. I am your hands and feet. Use me Lord."

What are you attached to...

Emotionally?

Mentally?

Spiritually?

Financially?

With your family?

Intimate relationship (or absence of one)?

With yourself and where you secretly hold you hostage?

What would you have to forgive, express empathy, have compassion for, or grant grace and mercy in order to set yourself free (for good) in each area?

Emotionally?

Mentally?

Spiritually?

Financially?

With your family?

Intimate relationship (or absence of one)?

With yourself and where you secretly hold you hostage?

Say In Substance

There is a calling on your life. You were crafted for a mighty purpose. Everything since the dawn of time has conspired to make you perfectly you. You are uniquely crafted and positioned to change the world. Healing your heart is the access to BEING who you need to be to fulfill your destiny.

It's not about the end result. It's not about you having a million dollars in your bank account. You may or may not reach the goal you have in your mind. Your calling is to BE who you need to be in this world, to so walk your talk (like Jesus, Gandhi, Dr. King, Nelson Mandela—the game-changers) you so DO YOU that even if you don't reach your mark, the course of human history is altered for the good. So you can't be attached to the outcome. It's the walk to the outcome that changes the world.

Look at each of these photos. On the first line, write down what the first word that comes to your mind when you see the image.

Madam C.J. Walker

Dr. King

Nelson Mandela

Toni Morrison

President John F. Kennedy

Mother Teresa

Michael Jordan

Oprah Winfrey

The Wright Brothers

Michelle Obama

Beyoncé

Jay-Z

President Barack Obama

Now go back through and right down on the second line, in one word, what did each game-changer stand for? *(Do that before you move on to the next part.)*

Now pick your favorite one. What do you admire most about that game-changer?

Here is the truth: you can only see in others that which is already you.

Whatever you saw in each game-changer is actually who you already are.

What you wrote down that each game-changer stands for is what you stand for.

And what you said you admired most in your favorite game-changer that is your calling. That is your BEING waiting to be expressed.

The being gives the doing. It tells you what to do. It orders your steps. When you take on consciously being what you most admire (now that you heart healed and there is room for Spirit to move through you) making millions that matter, with ease, fulfillment and authentic self-expression is a natural byproduct.

CONCLUSION:
THANK YOU FOR LETTING ME
CUSS YOU OUT

It's never easy to tell the truth.

There is always the fear of loss or punishment.

I wrote this book exactly the way I talk to my clients and the way Nanna talks to me—with ruthless compassion.

I have learned that love is not about agreeing.

If you love someone, you tell them the truth and trust that the love is big enough to cover the insult. And, well, let's just call a spade a spade: the truth is insulting. But it is also the only way to get free.

And I want you free.

My entire business is rooted in one very important truth I wanted to model for you and dare you to try: you can make millions, make your mark, and make a qualitative difference in other people's lives just by being yourself.

This book is my truth.

It is what I have been doing to heal my wounds for over 30 years, so I could set myself free.

Sis, are you willing to be free?

I mean in every possible way. Emotional and economic freedom is a direct result of healing historical and cultural wounds that get acted out in our present-tense personal lives. Way too often a sister will say she wants to

become a Black Woman Millionaire, but she refuses to stop giving her ex money. Or paying for her father's alcohol. Or life knocks her to her knees and she doesn't get up off the mat. And even if she does, she gets up timid. Playing safe. Scared of being knocked down again.

The biggest difference between you and me is this: you count how many times life knocked you down; I am counting how many times you got back up.

My point is this: Are you willing to change?

Don't say yes yet. I need you to understand what I mean.

When I became committed to leaving my day job because white privilege had shown its ass one too many times, I prayed to God to order my steps. I never imagined that Spirit would send me to a room of rich White Male CEOs who would pay me more money in one day than I made in a year. Just to tell them the truth about themselves in love and curse them out. It worked. And I have been doing it ever since.

I had to let go of being thought of as respectable. I had to accept my street instead of trying to change me. I had to learn how to market. I had to grow up emotionally and not fly off the handle whenever I felt talked down to—behaviors I had been doing for years. I had to learn how to trust myself. I had to build credibility with me. I had to move. I had to change my hair. I had to pay a shitload of money to hire mentors and experts at obscene amounts. At least for my background and me. It was so much money for a poor little Black girl from the streets that it made me want to vomit. Up until that point, it was more money than I had seen in my lifetime.

But what I had to really contend with were these three questions: Do I want my future to be different from the past I was born into? Do I want my life to be useful? Do I want to make God proud? And when I asked myself these questions, I cried, got myself cleared, and got back in the game.

So my prayer for you is that you will take what you have read and get up off the mat or get back in the game. I need you. The world needs you. Not everyone will hear me. I cuss too much. But they can hear you. Millions of people are waiting to be inspired by your walk. Let the world hear you. You are God made flesh. Trust that. Know that. And try.

Be willing to fail.

You will fail a lot. It took me over 30 years to write this book and get it published. Self-published. That's after being turned down by 30 major publishing houses in NYC who stated that Black Women would not by a book that taught them it was possible to become a millionaire. I have failed my way

into success. And with each failure, I became clearer about the next right action. And the next. And the next.

My point is this: it's never easy to tell the truth, but it's worth it for that which makes your life matter. I invite you to take your mess and turn it into a movement that can touch millions and make millions if that's what you want. And if it's not, no worries. Just make sure you are proud of you because you got back up off the mat.

Thanks for letting me cuss you out. It was done in love. I know that sounds fucked up, but it's the truth. I have already said this, but it's worth repeating: I love you enough to tell you the truth. And the truth is inherently insulting. But I did ask for permission. And you said yes. I thank you for being a yes. To me. To this walk. To yourself. I love you, sis. You give my life purpose. You make all the shit I walked through ... to get to you, my sweet sister in success ... worth it.

And for you, I am grateful.

Thank you.

Thank you.

Thank you.

With all the love my heart can hold ...

PS: Healing is a process.

Please go to www.DefyImpossible.com so we can stay connected and grow ... together. Plus, I have a love offering to get you started right away on your path to 7-figure success. I am honored to be your Millionaire Mentor—for the long haul ...

Also, meet me live on tour! Go to
www.TheBlackWomanMillionaire.com/tour

ONE LAST THING...

Here is the proposal that was turned down by 30 of the top publishing houses in NYC. The proposal was summated with the following title:

You Will Never Out Earn Your Self-Image
And Other Reasons Why Black Women's Relationship to Money Is Fucked & How To Heal It.

When I decided to self-publish, I decided this title was too long and shortened it to: The Black Woman Millionaire: A Revolutionary Act that DEFIES Impossible.

I am including the proposal as a teaching to for all of my sisters in success (and the brothers who love us) who may want to know what a quality book proposal—replete with a BEAST MODE marketing plan—looks like.

When I was learning about publishing a book, I had to buy someone's proposal just to see what was in it. I didn't want any future author to have to struggle with just getting started with a model that is completely true to self. While the publishing houses declined, the feedback my literary agency received, as well as from one of the publishing houses, was that my marketing plan was one of the best they had ever seen. So I offer this to you as a love

offering. My prayer for you is that this love offering instructs and inspires you to tell your story, standing—unapologetically—in your power.

Some Things You Should Know Before We Do This...

WARNING...

It's important to note: I am bilingual. Yes, I have a PhD from Stanford. But don't be fooled. I speak fluent "street." There is true genius in my Word, which happens to be liberally sprinkled with adult language. ONLY READ if you are open to some next-level thinking in service of your 7-figure destiny. If not, no worries. PUT THE BOOK DOWN. Save yourself the stress. I don't want you to feel dishonored and I don't want me suppressed. It took DECADES to love me as I am—completely imperfect, wounded, and street. So I am not offended if you are offended. I get it. Stop here. I honor your walk just as you honor mine.

WHAT HAPPENED WAS...

What you are about to experience is a project that 30 top publishing houses in New York City turned down. I was represented by one of the top literary agencies in North America. I have a PhD from Stanford. My company, Defy Impossible Inc. (which serves Black Women entrepreneurs), has grossed $4 million in the past five years without being a certified Minority Business, having a product, loan, grant, or seeking investors. When I asked my agent why everybody said no, I was told the executives said there isn't "a market" for Black Women who would buy a book about how to become a millionaire.

I don't agree with them.

So I hired a publicist, created a 10-stop tour, and self-published the proposal as the book to serve as a teaching/healing tool for my sisters in success ...

... and as a "fuck you" to the gatekeepers.

#itoldyouicurse #thebestrevengeisyourpaper #defyimpossible

NOT A BLACK WOMAN? READ AT YOUR OWN RISK...

It's okay.

I know you are not Black. Or a woman. Or both.

No worries. I am not mad. And I want you to know this: you are welcome here.

I put Black Women first. But first doesn't mean alone.

As long as you can respect the sacredness of this space, of this energetic "house," then we are good. Just please remember: you are a guest in my house. Please don't try to turn this into a fight. You. Will. Lose. #Iwishamotherfuckerwould #allmychristiansprayforme

With all the love my heart can hold…

The Book Proposal:

About the Author

I am Dr. Venus Opal Reese.

I know what it feels like to be a slave.

To live at the mercy of other people's pain.

To have to acquiesce to other people's agendas.

And it all started at home …

By the time I was sixteen, I was living on the streets. Doing everything I needed to do to survive.

But long before the streets, shit had been bad.

I come from a lineage of addicts, petty hustlers, and violence.

Crazy as it sounds, the streets were kinder to me than what happened during Momma's watch. From six to sixteen, the pills, the powder, and the police were my normal.

By the time I met the ninth grade math teacher who saved my life, my survival strategies were firmly established. I was used to picking up the crumpled dollar bills at the Tick Tock Club where the strippers twerked. I could no longer smell the urine and beer reeking from my body from the alley with the rats and roaches where I slept. I knew how to survive. I knew how to navigate the streets, to hear what people were *not* saying, and I knew loyalty was the difference between life and getting stolen. On the streets, death is a daily threat.

Simply put: survival and I roll hard. So believe me: I know survival.

I watched it in my house. I studied it for years in pimps, addicts, and cops. And I lived it on the streets. I can smell it on you. I can see it coming and going. It would be impossible for me not to have mastery at identifying survival and still be alive.

And here's the truth: It was my survival strategies that got me through my second master's degree and PhD from Stanford University. And it fast-tracked me to the seven-figure mark. Not my smarts or my skill. It was my ability to harness my survival that got me my four degrees, that got me featured in *Forbes* and showcased in *Ebony* magazine as one of four Black Millionaires

who turned our passion (or in my case, pain) into profit. I know survival—and how to pimp it. **You can see a complete list of my press clippings here:**
http://www.defyimpossible.com/speaking-press-clips/

Real talk: Black Women are wired to survive.

From chattel slavery, churches, and sororities, from nonprofits to corporate boardrooms, Black Women have been socially and economically positioned to be the workhorse, cash cow, scapegoat or beast of burden. For generation after generation we have been taught that to "work hard" and "be strong" is the way to financial affluence.

Lies. Working hard will *never* make you rich. It will only make you tired.

Working hard, being strong, overcoming, making it—and other slavery-based behaviors—were once survival strategies of our ancestors that have been passed down to us as cultural traits. Now, they are our "normal." Except these survival strategies will keep you broke and broken. I have taken my brokenness and turned it into a multimillion-dollar business, setting myself free both emotionally and economically. My calling is to teach my sisters in success how they can do the same. That is why this book needs to be written.

I don't think I am the best writer for this book.

I know I am the *only* writer who could write *this* book.

Why? Because I have lived it. I have taught it. And I have monetized it.

There are academics that can spit out knowledge better than I can … but they've never picked the seeds from a nickel or dime bag of weed to sell.

There are some business experts who can tell you how to start a business … but they haven't fast-tracked to $1.2 million in less than three years or $2.3 million in less than four—without an MBA, a physical product, or *any* sort of small business loan, venture capitalist or angel investor. #cashmoneybaby

And there isn't a White Man or Woman who gives a fuck about Black Women making our own paper or … (if I am being polite) truly understands the internal racism, external prejudices, and systemic social structures that keep Black Women economically depressed. I haven't seen a White economist commit her or his life to tending to the wounds of slavery and Black Women's money. Have you? If you have, please introduce us. I would love to compare notes and see whom Black Women will trust with their wounds and dreams.

Comp Titles

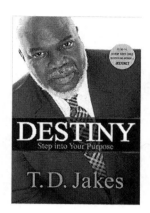

This book is an inspirational career guide in the same family as *The Four-Hour Workweek: Escape the 9-5, Live Anywhere, and Join the New Rich; Jump: Take The Leap of Faith to Achieve Your Life of Abundance*; and *Destiny: Step Into Your Purpose.* Each of these extraordinary books (and brilliant authors) addresses how life's struggles can be harnessed into the necessary fuel to free a person to fulfill their higher calling.

Each book uses life's lessons and pain to flesh out actionable principles that can be applied immediately to better the reader's life. And each book teaches the reader to realize that they are bigger than their breakdowns. This book has the same core message as these seminal texts, with an added dimension: accounting for the historical wounds of North American slavery, specifically on Black Women's sense of self as it relates to freedom and wealth.

Each of these books touches on how societal expectations and personal failure can be leveraged into abundance, wealth, purpose, and peace of mind. *Why Black Women's Relationship To Money Is F*cked & How To Heal It* goes a step further: it address and accounts for the <u>historical root</u> of those societal expectations that make people feel inadequate, unworthy, and diminished. What's more, NONE of these incredible books address the damage those expectations and social systems have had on a professional Black Woman's sense of self and her relationship to money. I love my brothers; each of these incredible authors has changed the game and enriched the genre. **<u>And</u>** there needs to be a book in this genre that speaks to one of the largest buyer's markets in North America: educated, successful Black Women.

If it helps, you can think of this book as the new and improved version of Glinda Bridgforth's *Girl, Get your Money Straight* (Crown, 2002). So much has happened in the past 15 years, the Obama Era has come and gone, and women of color need an empowering voice to transform their relationship to money and success.

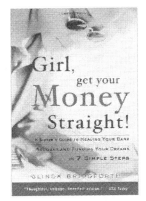

Audience

My book-buying audience consists of entrepreneurial Black Women whose heart has been broken by life.

My sisters in success are the first in their families to go to college, get a "good" job, buy a big house, or get a PhD. She ...

... is a hard-working sister with something to prove. She loves the Lord, listens to T.D. Jakes, and lives *The Secret* while she bows at the altar of New Thought/Ancient Wisdom taught by Rev. Dr. Michael Beckwith of Agape International.

... reads *Essence* and *O Magazine*. She watches *Scandal, Empire,* and *Being Mary Jane*. She lives in New York, Houston, Atlanta, Chicago, Florida, New Jersey, Los Angeles, Raleigh, Detroit, Washington DC, and Baltimore. She holds it down for her city with loyalty that rivals soldiers who have been in foxholes together.

... is a proud, passionate Black Woman with an edge on her. It may be hidden behind Southern charm or urban glamour—but this chick will rain truth down on you if you piss her off on the wrong day.

... is educated and accomplished, but not where she thought she would be *by now*. She knows she is smarter than her "higher-ups" as well as most of the people around her, but she doubts herself. She needs to be needed. Life kicked her in the teeth when she wasn't looking. She is brilliant but bruised. She feels alone. She has been hurt, betrayed, used, and pissed on. You can't tell, because she looks so polished. But the shine only covers the emotional and spiritual bruises too tender to touch.

... is a Black Woman who is working class and wants so badly to make good with her life. But she keeps making bad decisions that undermine her money and her sense of self.

... is a Black Woman executive with a six-figure-plus income from her "good job"—but she feels like a slave. She wants out, but the golden handcuffs chain her to her corner office with the view. She has a side hustle that she funds with her job, but doesn't want to break a sweat. She is comfortable—but unfulfilled.

... is a Black Woman in business who is *killing* herself trying to get this thing to work. She has a business, but it's not thriving. She makes money, but her behaviors have her give her money away to family, her church, or her boo.

She undercharges, over gives, and then feels guilty about doing both. She tends to self-sacrifice and then suffers over how no one is there for her.

... is conscious, aware of social changes, and will march for what she believes in.

... is proud of her heritage and will cut a bitch for saying some bullshit about race, Harriet or Malcolm, or Dr. King.

... will give her last dollar to a child in need or an elder who needs care. She won't tell anyone she can't make her car payment, but she will do *everything* she can see to do to take of those she loves—even if it means she goes without or has to take the hit.

I know all these women because I have been all of them.

And I met them on tour. I am telling their story—our story— in a language that we traffic in. My sisters will buy this book in droves, and they will cry.

They will rock and cry when they read this book. They will send sweet scented prayers to God in whispers and sobs because for once, they will feel like somebody—just. like. them.—made it out ...

... and didn't leave them behind.

Publicity and Marketing

When it comes to Publicity and Marketing, I focus first on leveraged strategic partners with whom I already have a robust relationship. As your partner in selling 300k copies of our book in 24 months or less, here is what I bring to the table to ensure success! You can see a complete list of my press clippings here:

http://www.defyimpossible.com/speaking-press-clips/

Combined reach of my tribe and my proven strategic partners: 3,581,748+

My Tribe

Here are my current numbers regarding **my reach: 109,673**

Facebook Public Figure:
52,976 fans
https://www.facebook.com/DrVenusOpalReese/

Facebook Personal:
5,000 limit friends
https://www.facebook.com/venus.reese

My private mailing list:
27,000
(trained to buy and *hungry* for this book!)

Twitter:
17,183 followers
https://twitter.com/dr_venusoreese

LinkedIn:
4,439 connections
https://www.linkedin.com/in/drvenusoreese

YouTube:
3,393 subscribers
https://www.youtube.com/user/DrVenusReese

Instagram:
 3,075 followers
 https://www.instagram.com/drvenusopalreese/

My Clients

My clients invest in big ways to work with me--some have mortgaged their homes; others have cashed in 401ks. But many sisters can't afford these rates--and it hurts me to see them struggle or break out in tears when they hear my rates. I know I can help more sisters, which is why I need to write this book now. The Masterminds include 4 retreats a year and 5 calls a month. Below is an example:

 23 invested in the 12-week webinar for $15k
 20 invested in Mastermind Baller at $18.5k
 17 invested in Shot-Caller at $27.5k
 18 invested in Platinum at $27.5K
 4 invested in Game Changer at $60k
 10 invested in Diamond at $60k
 5 invested in Mogul, $100k

Additional Reach

TV

I have my own reality TV show in the works. Here is a link to see me on tape: http://www.defyimpossible.com/video/#/ We can time the launch for the *New York Times* best-seller campaign with the premiere of the show in late 2017 or 2018.

Radio

I have been featured on the *Tom Joyner Morning Show*, reaching **8 million homes daily**, and his online platform multiple times, www.BlackAmericaWeb.com, with over **2,000,000 unique visitors a month.** Listed below are my interviews, articles, and videos on Tom's platform:

How Much Are You Worth to Yourself? An Interview with Dr. Venus by Nikki Woods, Senior Producer, The Tom Joyner Morning Show

http://blackamericaweb.com/2013/02/28/how-much-are-you-worth-to-yourself-with-dr-venus-opal-reese/

Jacque Reid Goes Inside Her Story with Dr. Venus Opal Reese

(aired to 8 million)

http://blackamericaweb.com/2012/08/10/jacque-reid-goes-inside-her-story-with-dr-venus-opal-reese/

How Your Self-Worth Defines Your Net Worth

http://blackamericaweb.com/2013/07/08/how-your-self-worth-defines-your-net-worth/

Self-Worth, Money, and Success for Sisters

http://blackamericaweb.com/2013/06/25/dr-venus-opal-reese-self-worth-money-success/

The Big Lie: Education = Financial Success

http://blackamericaweb.com/2013/06/17/entrepreneurship-financial-success/

The 'We Matter' Manifesto

http://blackamericaweb.com/2013/06/10/the-we-matter-manifesto/

Mamas Gone Wild, Episode #41: A Black Woman's True Value—Do You know Yours?

http://blackamericaweb.com/2012/08/15/mamas-gone-wild-episode-41/

Mamas Gone Wild, Episode #39: Street Strategies

http://blackamericaweb.com/2012/08/01/mamas-gone-wild-39/

Magazines

I have been a regular contributor to *Heart & Soul* Magazine/TV. The publication has a bi-monthly **circulation of 300,000 and a readership of more than 1.5 million.** *Heart & Soul* is the preeminent brand to promote the physical, mental, and spiritual well-being of women of color and their families, with 97% of its readership being African AmericanWomen. Link to my numerous contributions:

http://www.heartandsoul.com/?s=dr.+venus+Opal+reese

Strategic Partners

Dr. ███████████

Dr. ███████████ will mail to her extremely responsive list of ████ **paying members** who have been trained to buy. Here is her website:

http://www.██████████████

████████████ will promote with us for the *New York Times* best-seller campaign to her **tribe of** ████████ **(and growing).** She has trained her tribe to buy and is one of my top affiliates.

https://www.██████████████

Stanford University

Book signings under the auspices of ██████████████████ ███████████—an old friend who runs the center.

https://██████████.

Touring and Live Events

I do an annual Black Women Millionaires Blueprint tour: www.BWMBlueprint.com/tour

We generated **$289,215 in ticket sales.** There were two rates: Standard Access: $1,497, and Diamond Access: $4,997.

And I will also be doing a promo tour for my TV show. I plan to do a media tour for the book. With a bit of planning, we can have all three tours feed the *New York Times* best-seller campaign. As a marketer, I have learned that doing things in threes generates ten times the buzz and sales of any launch.

I have done two live events annually, which attracts a buying audience of entrepreneurial Black Women hungry to be fed. These two events grossed **$1,104,800** in 2016. The investment levels were Platinum: $27,500, Diamond: $60,000, and $100,000 for Mogul, as well as revenue generated from guest speakers.

Event website: www.BlackWomenMillionairesEvent.com,

Online Launches

I would include the book in each of my online launches as a paid-in-full bonus.

I can reach up to **500,000 Black Women on Facebook Live.** So when we take on the *New York Times* best-seller campaign, I will schedule three Facebook live streams for that week promoting the goal and enrolling my tribe as my partners in making history. My last two FB live streams in the last two weeks have each had over 10k views.

Additional Strategies

Below are a few ideas to increase marketing efforts for the book:

- Have the Top 10 Black Women Bloggers review the book and promote to their following.
- College Campuses Speaking—specifically HBCUs, women's centers, and universities that have an entrepreneurism track or degree program.

- Post-Graduate Black Sororities—these sisters have monthly and annual meetings where I can do a talk and a book signing. We could also see about selling books in bulk in advance.
- Black Professional Associations— each association has a committee or a commitment to enrich the women they represent. I will reach out to these organizations and can design a talk around the book and have a book signing at their local or annual meeting:

African American Planning Commission (AAPC)
http://aapci.org/site/

American Association of Blacks in Energy (AABE)
http://www.aabe.org/

The Association of Black Psychologists
http://www.abpsi.org/

The Executive Leadership Council
https://www.elcinfo.com/

Information Technology Senior Management Forum
http://www.itsmfonline.org/

Joint Center for Political and Economic Studies
http://jointcenter.org/

National Action Council for Minorities in Engineering (NACME)
http://www.nacme.org/

National Association for the Advancement of Colored People (NAACP)
http://www.naacp.org/

National Association of Black Accountants, Inc.
http://www.nabainc.org/

National Association of Black Journalists
http://www.nabj.org/

National Black Chamber of Commerce (NBCC)
http://www.nationalbcc.org/

National Black Justice Commission
http://nbjc.org/

National Black MBA Association
https://nbmbaa.org/

National Black Nurses Association (NBNA)
http://www.nbna.org/

National Council of Negro Women, Inc. (NCNW)
http://www.ncnw.org/

National Coalition of 100 Black Women (NCBW)
http://www.ncbw.org/

National Medical Association (NMA)
http://www.nmanet.org/

National Urban League
http://nul.iamempowered.com/

National Society of Black Engineers (NSBE)
http://www.nsbe.org/home.aspx

Organization of Black Designers
http://obd.org/

United Negro College Fund (UNCF)
https://www.uncf.org/

100 Black Men of America
http://100blackmen.org/

Where Black People Hang Out

I would love to be a sponsor, speaker, or having a booth at these highly attended events to create great platforms for this book:

Essence Music Festival
https://www.essence.com/festival

Fantastic Voyage Cruise with Tom Joyner
https://fantasticvoyage.blackamericaweb.com/

The Neighborhood Awards with Steve Harvey
http://www.neighborhoodawards.com/

National Black Caucus Convention
https://www.cbcfinc.org/annual-legislative-conference/

NAACP Image Awards
http://www.naacpimageawards.net/

Black Enterprise Women of Power Summit
http://www.blackenterprise.com/events/

Angel Investing—*Shark Tank* Style

In 2018, I plan on holding a pitch contest, "Who Wants to be a Black Woman Millionaire?" I will be **investing my own money (either $25k, $50k or $100k)** to provide a Black Woman in Business with the right mentorship and capital so she can become a Black Woman Millionaire in one to three years. This is part of my business strategy. I will require all potential contestants worldwide to read my book *before* applying.

Start a Movement
Community Involvement

I would like to send early drafts of a sample chapter to my tribe and ask them to create discussion groups to talk about what they have read and post their thoughts in a Facebook Community or on my Fan page. These groups

would become our "champions" for the book and will be our foot soldiers to drive women to the tour stop in their city to buy the book. We can even have the person who is most engaged with the discussion group introduce me, and I can give her a gift for being a "champion" of Black Women.

College Campuses and Curriculum

We can also extend this strategy to college campuses and look to see how to have the book become required reading for Women's studies, African American studies, Queer studies, and MBAs. If not, I can do a talk at colleges—we can target Ivy League schools and really focus on their Black Female populations, graduate and undergraduate.

Black History Month and Women's History Month will be great months for this book—especially for the 10,000 in one week for *New York Times* best-seller status.

I'll stop here.

I genuinely enjoy marketing. I am your full partner in leveraging my proven platform, relationships, and sheer genius in empowering Black Women to invest in themselves. Believe me when I tell you—$25 is *unheard of* on my campus. The price point makes it accessible to all the sisters who have wanted to pay the $1,997 or the $10k for VIP day or the $100k for a yearlong private mastermind—but couldn't. This book is a godsend for sisters to be a part of a movement that meets them right where they are.

From here, my proposal went on to include a table of contents – and the book you just read, complete with the worksheets and examples. My prayer is that by including the proposal, you get a teaching tool that will empower you to speak you truth—even when the World says no—and to turn pain your into profit.

ABOUT THE AUTHOR

Dr. Venus, The Black Women Millionaires Mentor™, is an acclaimed international speaker; CEO Mindset, Messaging and Marketing Mentor; and entrepreneur coach with a sweet spot for teaching primarily Black Women in business how to break the million dollar mark—on their own terms. Dr. Venus went from living on the streets and eating out of trashcans to obtaining two master's degrees and a Ph.D. from Stanford University. She worked as a university professor before investing in herself by testing her entrepreneurial skills. Her business, Defy Impossible, grossed $ 4 million five years after launching. Her clients have grossed $8 million in seven years implementing her proven strategies and systems.

Learn more and claim your free gift at www.DefyImpossible.com

ADDITIONAL TITLES

Live Sassy Formula: Make Big Money and a Big Difference Doing What You Love!
>ISBN-13: 978-0985239800
>*(Contributing Author)*

Succeeding In Spite of Everything
>ISBN-13: 978-0981970899
>*(Contributing Author)*

Money Mogul Map: Chart Your Way to 7-Figure Success—On Your OWN Terms!
>ASIN: B01N0ETEEL

Made in the USA
Middletown, DE
01 February 2018